CHINA

Photographs by Christina Lionnet

CHINA

Photographs by Christina Lionnet

teNeues

TO THE PEOPLE OF CHINA,
WHO WELCOMED ME
AND WHO OFFERED THEIR
SMILES TO MY LENS

TO MY FAMILY

敬献给给予我热情招待和在镜头中微笑的所有中国人，以及我的家人。

INTRODUCTION

"Five times I came back, at different periods," wrote the consul Auguste François[1] in 1904, on the point of leaving China. "For eleven years I lived in this grimy worn-down, thread-bare China, never ceasing to feel its pull, never ceasing to feel the astonishment, the curiosity and the interest that emanate from this enormous thing, from this strange world, from the hugeness of it. I've wandered its soil, its rivers, for thousands of leagues; my shoes have trod more than eight thousand kilometers of its roads. I no longer expect anything unknown to crop up, and yet on the verge of leaving China, I feel myself pulled by a sort of vertigo into its mass, drawn to embrace its immensity."

"Immense," "huge," and magnificent, China is that, assuredly. Diverse, dense, ever-changing, China cannot be simplified, and resists categorization. That is why China is still, and will always be, a fascination. Full of contrasts, it is a challenge for the geographer or ethnographer. For photographers, China is quite simply a visual feast.

Some photographers come to China with a single goal: to publish a book. This was not the case for me. I came to China to live there. The desire to know the country through human connections preceded—and generated—that of knowing it through the camera lens. Four years later, the wish to create a book came to me, simply because books are always a wonderful way of sharing: they permit the distant person to come closer, the immobile to travel, the curious to have their fill.

On the eve of leaving China, I felt that, in the end, three elements had marked me, seduced me in this country; elements which led to three chapters:

—the human richness of the territory. Not the "billion three" population that the newspapers are full of, but rather this multitude of communities which form the country's astonishing cultural mosaic: the China of rural and city communities; China by turns Buddhist, Muslim, or Christian; nomadic China where one imagined only sedentary populations; polyandrous China where the "one child policy," based on one man-one woman marriages, is often thought to rule over all Chinese families. Throughout the chapter "Chinese People," you will encounter the smiles of a few of the many people who welcomed me into their country for four years.

—"Chinese Things": these are the innumerable objects, dull or colorful, flashy or worn, beautiful or ugly, which form the visual landscape in China. From the start when for the first time you set your foot on Chinese soil, you distinguish nothing but a roiling mass of things new and unknown. Then, little by little, some of them emerge from the mass. They are, for instance, the coloured heads on Chinese mops, or the curved edges of dumplings. These simple little things are for me as symbolic of the country as the Summer Palace or the Forbidden City. It is those things of which one can say, years after leaving China, that they send us back—a little like Proust's madeleines, which is to say with certainty and emotion—to the Chinese universe.

—"Chinese Places," that is the marvelous painter's palette of landscapes which appear before our eyes, from the deserts of western Xinjiang to the borders of the Yellow Sea in the east, from the snow-covered prairies in northern Heilongjiang to the luxuriant green fields bordering Burma in the south.

Three themes, then, like three windows giving the reader a quick look at this intoxicating country, a glimpse of the colors and a sniff of the scents. My only wish is that, at the end of this pictorial voyage, the reader will reflect, using the writer Xinran's phrase, that China "has more flavors than just sweet and sour pork!"

Christina Lionnet

[1] Auguste François, *Le mandarin blanc*, Editions L'Harmattan, Paris, 2006.

EINLEITUNG

„Fünf Mal bin ich zurückgekehrt, jedes Mal zu einer anderen Zeit", schrieb der französische Konsul Auguste François[1], als er 1904 China verließ. „Elf Jahre habe ich in diesem armseligen, ausgezehrten, verknöcherten China verbracht, ohne dass jemals seine Anziehungskraft nachgelassen hätte; Staunen, Neugier und Interesse für dieses riesige Land, diese fremde Welt und ihre Monstrosität gingen nie verloren. Ich habe das Land durchquert, bin seinen Flüssen gefolgt, habe Tausende von Meilen zurückgelegt; bin mehr als achttausend Kilometer auf Wegen gewandert, die sich Straßen nennen; ich erwarte eigentlich keine Überraschungen mehr und dennoch, in dem Moment, wo ich China verlasse, spüre ich einen unwiderstehlichen Drang, mich von neuem in diese Masse zu stürzen, dieses Riesenland zu umrunden."

„Riesig", „monströs" und großartig ist China ohne Zweifel. Voller Gegensätze, unvorstellbar reich, mit wechselnden Gesichtern entzieht es sich jeder Vereinfachung und Kategorisierung; das macht seine ungebrochene Faszination aus. Kontrastreich und vielgestaltig stellt es eine Herausforderung für Geografen und Ethnologen dar. Für Fotografen ist es ein Geschenk, anders lässt es sich nicht sagen.

Manche von ihnen kommen mit dem Ziel nach China, ein Buch zu machen. Das galt nicht für mich. Ich bin nach China gekommen, um dort zu leben. Die Lust, das Land durch menschliche Kontakte kennen zu lernen, war zuerst da und erst danach – und dadurch – kam der Wunsch, es durch das Objektiv der Kamera zu erforschen. Nach vier Jahren entstand der Gedanke an ein Buch aus dem einfachen Grund, dass Bücher andere an den eigenen Erfahrungen teilhaben lassen: Bücher überwinden Entfernungen, ermöglichen den Unbeweglichen das Reisen, stillen den Wissensdurst der Neugierigen.

Kurz bevor ich China verließ, wurde mir klar, dass mich drei Aspekte dieses Landes geprägt, verführt und gefangen genommen hatten, drei Aspekte, aus denen drei Kapitel entstanden:

– der menschliche Reichtum dieses Landes; und damit ist nicht bloß die Zahl von 1,3 Milliarden Bewohnern gemeint, sondern eher die Vielzahl an Gemeinschaften, die das erstaunliche ethnische Mosaik des Landes bilden: ein ländliches China und ein städtisches China, ein China, das sich abwechselnd buddhistisch, muslimisch oder christlich zeigt, Nomadentum, wo man Sesshaftigkeit erwartet, Polyandrie, wo man Unterwerfung unter das Gesetz erwartet, das Ein-Kind-Familie und Einehe vorschreibt. Sie werden in dem Kapitel „Menschen aus China" den lächelnden Gesichtern dieser Männer und Frauen begegnen. Es sind einige von denen darunter, die mich während der vier Jahre in ihrem Land aufgenommen haben.

– die „Gegenstände aus China": unzählige Objekte, farblos oder bunt, verführerisch glänzend oder schäbig, schön oder hässlich, die die visuelle Gestalt Chinas bestimmen. Zu Anfang, wenn man chinesischen Boden betritt, nimmt man nur eine verwirrende Fülle neuer, unbekannter Dinge wahr. Später treten bestimmte Sachen hervor; z. B. die bunten Fransen chinesischer Besen oder die besondere Form der Nudeltaschen. Diese kleinen, unbedeutenden Details haben für mich eine ebenso symbolische Bedeutung wie der Sommerpalast oder die Verbotene Stadt. Von ihnen lässt sich sagen, dass sie uns, auch Jahre nachdem wir das Land verlassen haben, wieder in die Welt Chinas zurückversetzen – garantiert und mit allen Sinnen, ein bisschen wie die Madeleines bei Proust.

– bestimmte „Orte in China", eine wunderbare Palette von Landschaften, natürlich oder künstlich, die China vor unseren Augen entfaltet: von den Wüsten von Xinjiang im Westen bis zu den Ufern des Gelben Meeres im Osten, von den verschneiten Prärien von Heilongjiang im Norden bis zu den Gebieten an der Grenze zu Birma mit ihrem feuchten Klima.

Drei Themen wie drei Fenster, die uns einen Ausblick auf dieses verwirrende Land eröffnen, gerade ausreichend, um einen flüchtigen Eindruck von seinen Farben und Gerüchen zu erlangen. Mein einziger Wunsch ist, dass der Leser auf dieser Bilderreise erkennt, um die Worte des Schriftstellers Xinran zu verwenden, dass China eben „nicht nur einen einzigen Geschmack hat, den von süßsaurem Schweinefleisch"!

Christina Lionnet

[1] Auguste François, *Le mandarin blanc*, Editions L'Harmattan, Paris, 2006.

INTRODUCTION

« Cinq fois je suis revenu, à des époques différentes », écrit le consul Auguste François[1] en 1904, au moment de quitter la Chine. « Onze années j'ai vécu dans cette Chine pouilleuse, usée, râpée, sans cesse d'en ressentir l'attirance, sans avoir épuisé l'étonnement, la curiosité et l'intérêt qui se dégagent de cette chose énorme, de ce monde étrange, de sa monstruosité. J'ai parcouru son sol, ses fleuves, sur des milliers de lieues ; mes semelles même ont couvert plus de huit mille kilomètres de ce qu'on nomme des routes ; je n'attends plus beaucoup d'inconnu et cependant, au moment de la quitter, cette Chine, je me sens entraîné par une sorte de vertige à m'enfoncer encore dans sa masse, à faire le tour de son énormité. »

« Enorme », « monstrueuse » et magnifique la Chine l'est, assurément. Diverse, touffue, changeante, elle résiste à la simplification, à la catégorisation. C'est pourquoi, encore et toujours, elle fascine. Contrastée et multiforme, elle est un défi pour le géographe ou l'ethnologue. Pour les photographes elle est un régal, tout simplement.

Certains d'entre eux sont venus en Chine avec un but : réaliser un livre. Cela n'a pas été mon cas. Je suis venue en Chine pour y vivre. L'envie de connaître le pays à travers les rapports humains a précédé – et généré – celle de le connaître à travers l'objectif. Après quatre ans, le souhait d'un livre est apparu, simplement parce que les livres sont toujours une jolie forme de partage : ils permettent au lointain de se rapprocher, aux immobilisés de voyager, aux curieux de se rassasier.

A la veille de quitter la Chine j'ai senti que, finalement, trois éléments m'avaient marquée, séduite et captivée dans ce pays, qui ont donné naissance à trois chapitres :

– la richesse humaine de ce territoire. Non pas le « milliard trois » dont parlent les journaux, mais plutôt cette multitude de communautés qui forment l'étonnante mosaïque culturelle du pays : Chine des ruraux et des citadins, Chine qui se montre tour à tour bouddhiste, musulmane ou chrétienne, Chine nomade quand on la croirait sédentaire, Chine polyandre quand on la pense totalement soumise à la loi de l'enfant et du mariage uniques. Vous rencontrerez donc, au fil du chapitre « Gens de Chine », quelques sourires de ces hommes et de ces femmes. Quelques uns seulement, parmi tous ceux qui pendant quatre ans m'ont accueillie dans leur pays.

– les « choses de Chine » : ce sont les innombrables objets, ternes ou colorés, clinquants ou râpés, beaux ou laids, qui forment le paysage visuel chinois. Au départ, lorsque l'on pose pour la première fois le pied sur le sol chinois, on ne distingue rien qu'une masse grouillante de choses nouvelles, inconnues. Puis, petit à petit, certaines d'entre elles émergent. Ce sont, par exemple, les franges colorées des balais chinois ou les courbes des raviolis. Ces petits riens sont pour moi aussi symboliques du pays que le Palais d'Été ou la Cité Interdite. Ce sont eux dont on pourrait dire, des années après avoir quitté la Chine, qu'ils nous renvoient – un peu à la manière de la madeleine de Proust, c'est-à-dire avec certitude et émotion – à l'univers chinois.

– Les « coins de Chine », c'est-à-dire la merveilleuse palette des paysages, naturels ou domestiques, que la Chine déploie devant nos yeux, des déserts du Xinjiang (le grand ouest chinois) aux rives de la Mer Jaune et des prairies enneigées du Heilongjiang (nord) aux confins humides de la Birmanie.

Trois thèmes, donc, comme trois fenêtres pour un tout petit aperçu sur cet enivrant pays, permettant juste d'en entrevoir les couleurs et d'en humer les saveurs. Mon seul souhait serait qu'au terme de ce voyage en images le lecteur se dise, pour reprendre les termes de l'écrivain Xinran, que la Chine « n'a pas un seul goût, celui du porc sauce aigre douce » !

Christina Lionnet

[1]Auguste François, *Le mandarin blanc*, Editions L'Harmattan, Paris, 2006.

INTRODUCCIÓN

"He regresado cinco veces en épocas diferentes. He vivido once años en esta China piojosa, manida, raída, sin dejar de sentir la atracción, sin haber agotado el asombro, la curiosidad y el interés que se desprenden de esta cosa enorme, de este mundo extraño, de su monstruosidad. He recorrido su suelo, sus ríos, he estado en millares de lugares; mis propias suelas han cubierto más de ocho mil kilómetros de eso que llaman carreteras; no espero encontrar muchas más cosas desconocidas y sin embargo, en el momento de abandonar esta China siento un especie de vértigo que me impulsa a hundirme todavía más en su masa, a dar la vuelta a su enormidad." Así se expresaba el cónsul Auguste François[1] al marcharse de China en 1904.

"Enorme", "monstruosa" y magnífica. No cabe duda de que China es todo eso. Diversa, densa y cambiante, se resiste a la simplificación y a la categorización. Por eso es por lo que sigue fascinando y fascinará siempre. Llena de contrastes y de formas diferentes, constituye un desafío para el geógrafo o el etnógrafo. Pero para los fotógrafos es simplemente un placer.

Algunos de ellos vinieron a China con un fin: realizar un libro. Éste no fue mi caso. Yo vine a China para vivir en ella. El anhelo de conocer el país a través de las relaciones humanas ha precedido (y generado) el de conocerlo a través del objetivo. Al cabo de cuatro años surgió el deseo de elaborar un libro, simplemente porque los libros son siempre una bonita manera de compartir: permiten acercarse al que está lejos, viajar a los que están inmovilizados y resarcirse a los curiosos.

El día antes de partir de China sentí que, después de todo, en este país me habían marcado, seducido y cautivado tres elementos que han dado origen a tres capítulos:

– la riqueza humana de este territorio. No mil trescientos millones de habitantes de los que hablan los periódicos, sino más bien esta multitud de comunidades que forman el mosaico cultural del país: la China de los campesinos y los urbanitas, la China que unas veces se revela budista y otras, musulmana o cristiana. La China que resulta ser nómada cuando se la creía sedentaria, la China poliándrica cuando uno la imagina totalmente sometida a las leyes del matrimonio y el hijo únicos. Así pues, a lo largo del capítulo "Gentes de China" encontrará algunas de las sonrisas de estos hombres y mujeres. Sólo son unos cuantos de todos los que durante estos cuatro años me han acogido en su país.

– Las "cosas de China": son los innumerables objetos tenues o coloridos, relucientes o raídos, hermosos o feos, que forman el paisaje visual chino. Al principio, la primera vez que se pisa su suelo no se distingue más que una masa bullente de cosas nuevas, desconocidas. Después, poco a poco, algunas de ellas salen a la superficie. Son, por ejemplo, las franjas de colores de las escobas chinas o las formas de los raviolis. Para mí, estas pequeñas naderías simbolizan el país tanto como el Palacio de Verano o la Ciudad Prohibida. Se podría decir, que son estas cosas las que años después de abandonar China nos siguen devolviendo a su universo con certeza y emoción.

– Los "rincones de China", es decir, la maravillosa paleta de paisajes naturales o domésticos, que China despliega ante nuestros ojos, desde los desiertos del Xinjiang (el gran oeste chino) hasta las orillas del Mar Amarillo y de las praderas nevadas del Heilongjiang (el norte) a los confines húmedos de Birmania.

Tres temas que, como tres ventanas abiertas a una pequeña visión de conjunto, sólo nos permiten entrever sus colores y embriagarse con sus sabores. Mi único anhelo sería que al término de este viaje en imágenes el lector se dijera, retomando las palabras del escritor Xinran, "que el sabor de China no se reduce solamente ¡al del cerdo en salsa agridulce"!

Christina Lionnet

[1] Auguste François, *Le mandarin blanc*, Editions L'Harmattan, Paris, 2006.

INTRODUZIONE

"Cinque volte sono ritornato, in epoche diverse", scrive il console francese Auguste François[1] nel 1904, in procinto di lasciare la Cina. "Ho vissuto undici anni in questa Cina miserabile, consunta, logora, senza cessare di sentirmene attratto, senza avere esaurito lo stupore, la curiosità e l'interesse che si sprigionano da questa cosa enorme, da questo mondo strano, dalla sua *mostruosità*. Ho percorso la sua terra, i suoi fiumi, per miglia e miglia, le mie suole hanno macinato più di ottomila chilometri di cosiddette strade; non mi aspetto più molto di ignoto eppure, al momento di lasciare questa Cina, mi sento spinto da una sorta di vertigine a sprofondare ancora nella sua massa, a fare il giro della sua enormità."

"Enorme", "mostruosa" e magnifica la Cina lo è sicuramente. Variegata, sovrabbondante, mutevole, resiste a qualsiasi semplificazione e categorizzazione. È per questo che continua, ancora e sempre, ad affascinare. Con i suoi contrasti e la sua varietà, la Cina è una sfida per il geografo o l'etnologo. Per i fotografi è semplicemente una delizia.

Alcuni di loro sono venuti in Cina con uno scopo: realizzare un libro. Io no. Io sono venuta in Cina per viverci. Il desiderio di conoscere il paese attraverso i rapporti umani ha preceduto – e generato – quella di conoscerlo attraverso l'obiettivo. Dopo quattro anni, è nato il desiderio di fare un libro, semplicemente perché i libri sono sempre una bella forma di condivisione che permette a ciò che è lontano di avvicinarsi, a chi sta fermo di viaggiare, ai curiosi di soddisfare la propria curiosità.

Al momento di lasciare la Cina, ho sentito che, alla fine, erano tre gli elementi di questo paese che mi avevano colpita, sedotta e avvinta e che hanno dato origine a tre capitoli:

– la ricchezza umana del territorio. Non "il miliardo e tre" di cinesi di cui parlano i giornali, ma piuttosto la moltitudine di comunità che formano lo stupefacente mosaico culturale del paese: la Cina rurale e la Cina urbana, la Cina che si mostra ora buddista, ora musulmana, ora cristiana, la Cina nomade piuttosto che sedentaria, la Cina poliandra piuttosto che quella sottomessa alla legge del figlio e del matrimonio unico. Nel capitolo "Gente di Cina" incontrerete dunque il sorriso di alcuni di questi uomini e di queste donne. Solo alcuni, tra tutti coloro che per quattro anni mi hanno accolta nel loro paese.

– le "cineserie": gli innumerevoli oggetti, scialbi o colorati, vistosi o frusti, belli o brutti, che formano il paesaggio visivo cinese. All'inizio, quando si posa per la prima volta il piede sul suolo cinese, non si distingue altro che una massa brulicante di cose nuove, sconosciute. Poi, poco a poco, emergono alcuni oggetti, come, ad esempio, le frange colorate delle scope cinesi o la curva dei ravioli. Questi dettagli insignificanti sono per me altrettanto simbolici di questo paese quanto il Palazzo d'Estate o la Città Proibita. Sono queste piccole cose che ci rimandano, alcuni anni dopo aver lasciato la Cina, un po' alla maniera della madeleine proustiana, cioè con certezza ed emozione, all'universo cinese.

– gli "angoli della Cina", ossia la meravigliosa gamma dei paesaggi, naturali o domestici, che la Cina dispiega davanti ai nostri occhi, dai deserti del Xinjiang (il grande ovest cinese) alle rive del Mar Giallo e delle praterie innevate dell'Heilongjiang (nel nord) ai confini umidi della Birmania.

Tre temi, dunque, tre finestre per un piccolissimo spaccato di questo paese inebriante, che permette appena di intravederne i colori e di inalarne i sapori. Il mio unico augurio è che, al termine di questo viaggio, il lettore si dica, per riprendere le parole dello scrittore Xinran, che la Cina "non ha un gusto solo, quello del maialino in agrodolce"!

<div align="right">Christina Lionnet</div>

[1] Auguste François, *Le mandarin blanc*, Editions L'Harmattan, Paris, 2006.

前言

1904年,在即将离开中国的时候,法国领事奥古斯特.弗朗索瓦在他的手记《晚清纪事》中写到:他在中国生活了11年,这期间他走遍了这里的名山大川,走了数千公里,中国一直让他感到惊讶并吸引着他,从未中断过。我在这个巨大的、变化无穷的国家只生活过四年,但是我拥有与他同样的感受。

的确,我们不可能简单地给中国下一个定义,更不可能给她归类。这就是为什么她始终吸引着外国友人的原因。这样一个汇聚着多种风光、多种文化和多种民族的国家,对于地理学家和人类学家而言是一种挑战,对于摄影家而言却是一种享受。

一些摄影家来中国的唯一目的是完成一本书,但这不是我最初的动机。我来到中国是为了在这里生活。我的第一个愿望是想先通过人与人之间的关系认识这个国家,后来才产生了通过镜头来认识她的渴望。四年以后,自然而然地,出书的想法产生了,因为我始终觉得书是一种很好的分享方式:它能够让远在异地的人接近书中描述之地;能够让无法活动的人 "旅行";能够让好奇的人心满意足。

最终,这个富有诱惑力和吸引力的国家给我留下了三个方面的深刻印象,这也正是书中的三个章节:

这个国家文化的丰富,不仅仅是因为她的人口众多,更重要的是这样一个多民族同居,多群体共存的国家形成了一股令人惊讶的文化洪流:中国的农村和城市;中国众多的宗教信仰,如佛教、伊斯兰教或基督教;中国的定居人口和游牧民族;中国的一夫一妻制及独生子女政策和存在多夫制的少数民族等等这一切,让我们感受到中国文化的多样性和丰富性。因此,你们将会通过《中国人》看到某些男人和女人们的笑脸。你们也可以看到一小部分在这四年之中热情接待过我的中国人。

《中国物品》:是一些不可胜数的东西,平庸的或是生动的;美丽的或是难看的;构成了中国最直观的风景。一开始,当我们的脚第一次踏上中国土地的时候,我们无法区分周围大量新鲜的事物。接着,其中的一些开始慢慢浮现出来。比如, 中国特有的五颜六色的条纹拖把,或者中国饺子特有的弯曲度等这些微小的细节对我来说就像颐和园和紫禁城一样,也是象征中国的一种符号。可以说正是因为这些小小的细节,在离开中国数年之后,会让我回想起曾经生活过的中国,也让我感动。

《中国风景》,也就是许多不同的天然或人工风景区,令人赞叹不已。中国因此展现在我们眼前,从新疆的沙漠戈壁一直到黄海海岸,从黑龙江积雪的牧场草地一直到缅甸边境的茂密丛林。

这本书中的三个主题,好似三个窗口让人们对这个迷人的国家粗略地一瞥,同时也向不了解中国的人们揭示一点她的奥秘。我希望读者看完这本书之后,渴望来到中国,来发现中国,来认识这里的中国人。

Christina Lionnet

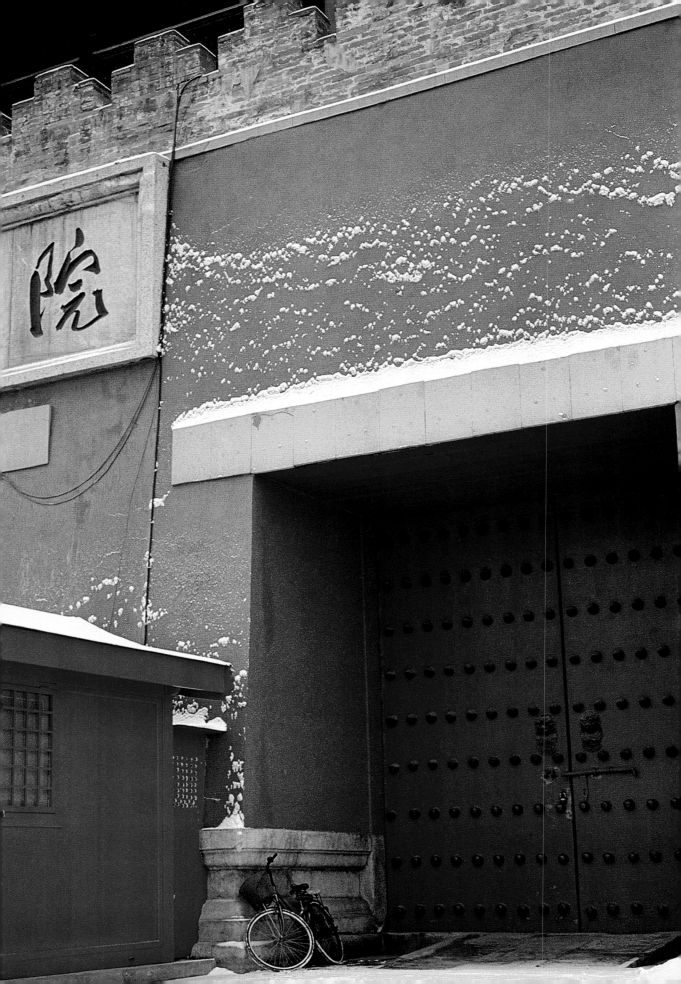

CHINESE

PEOPLE

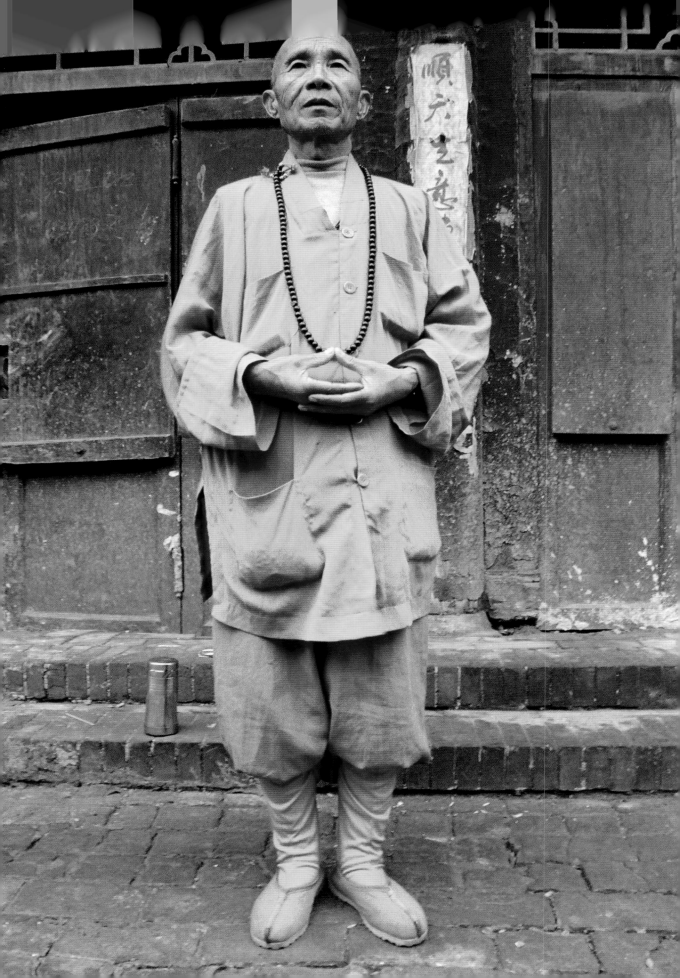

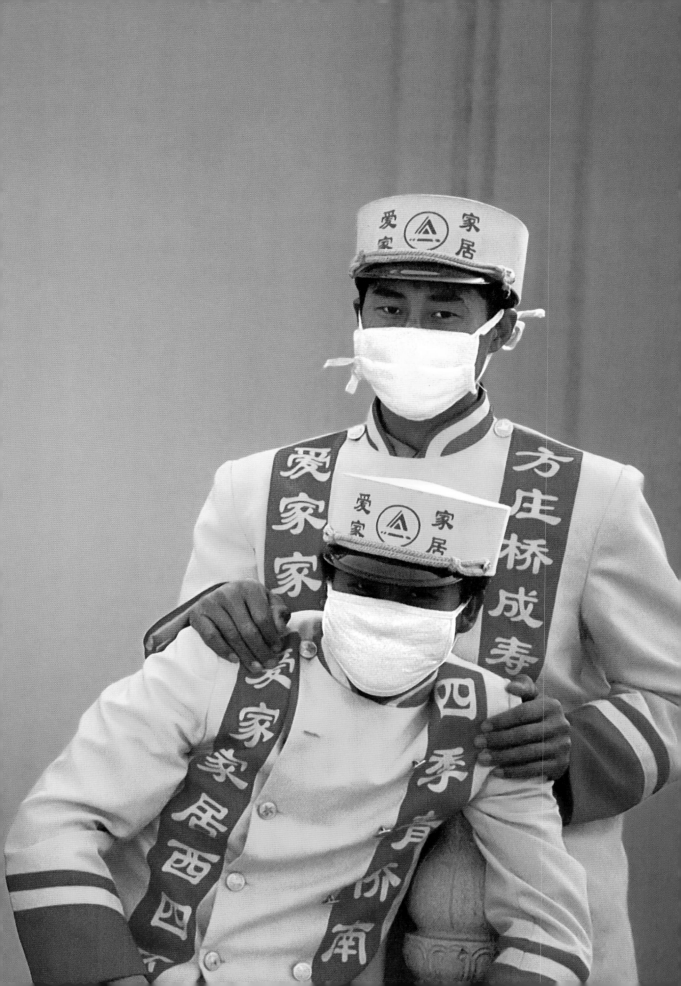

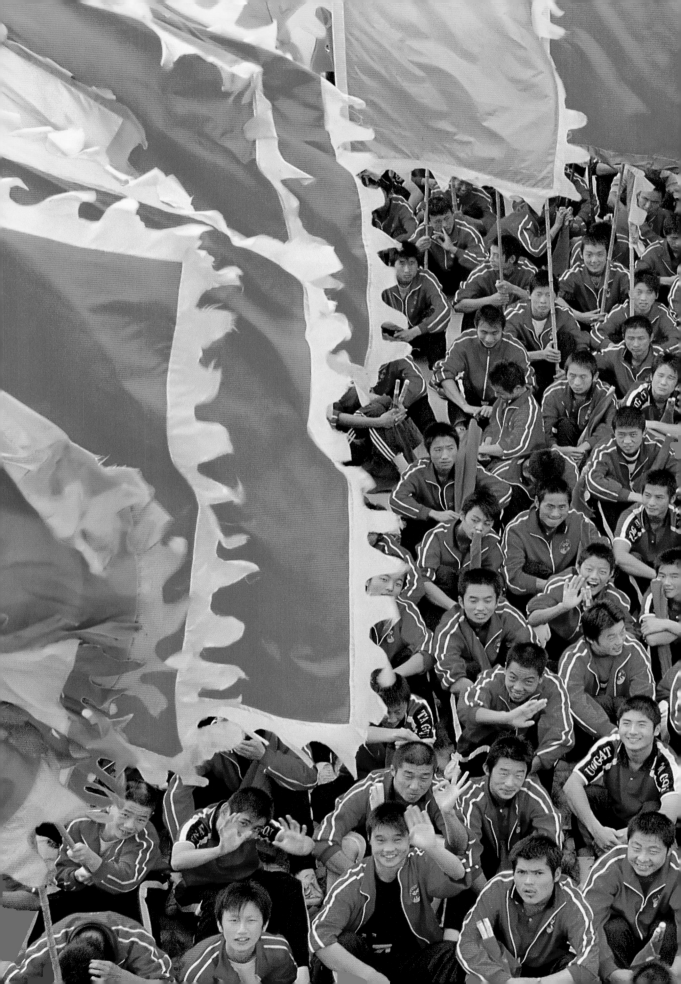

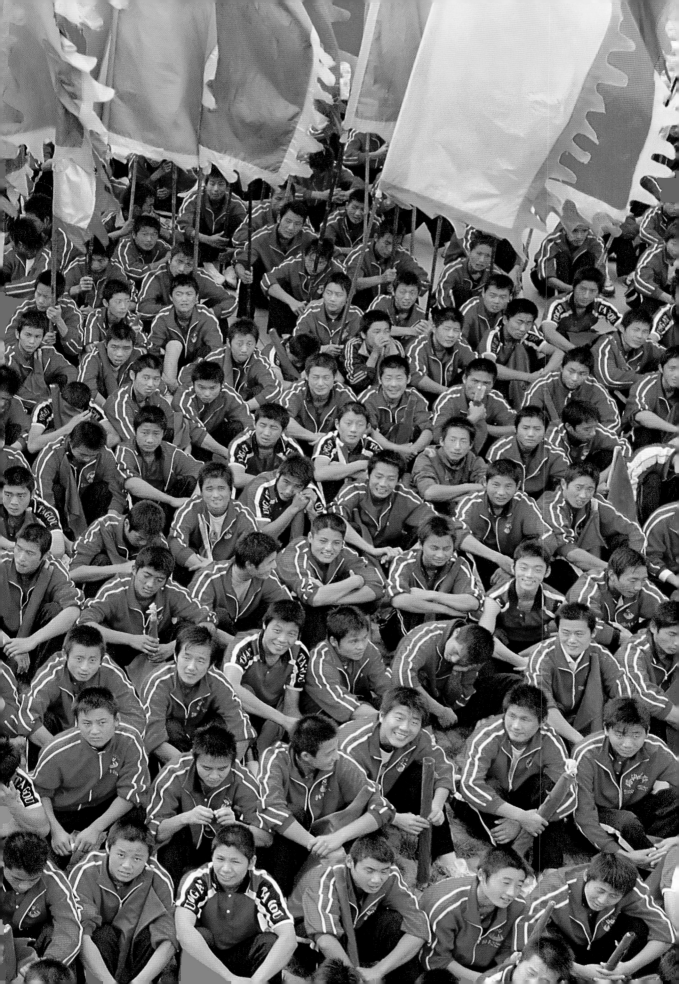

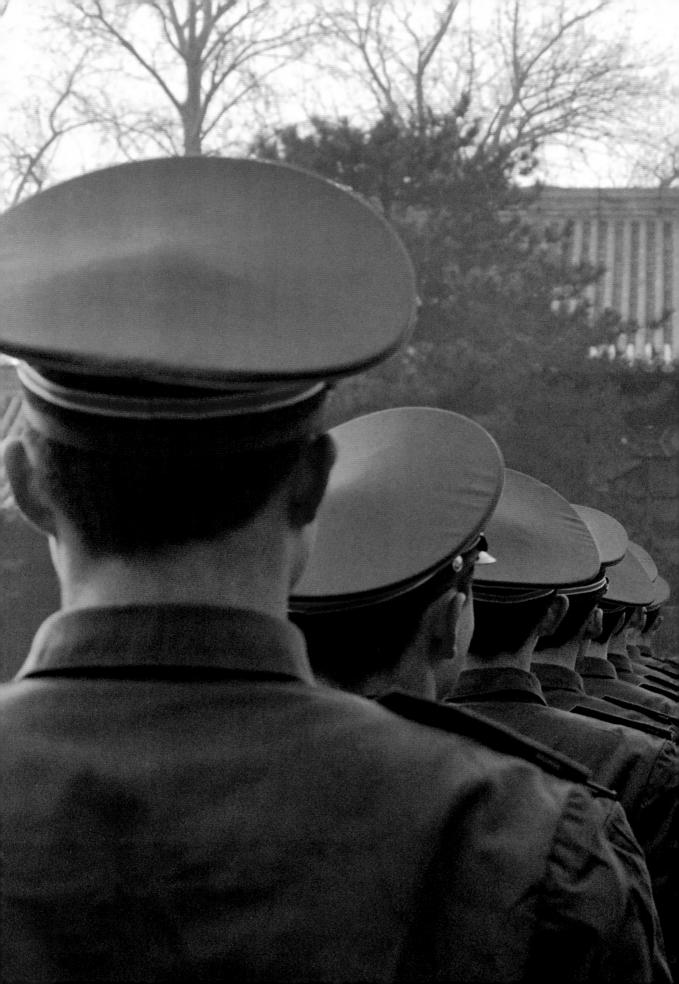

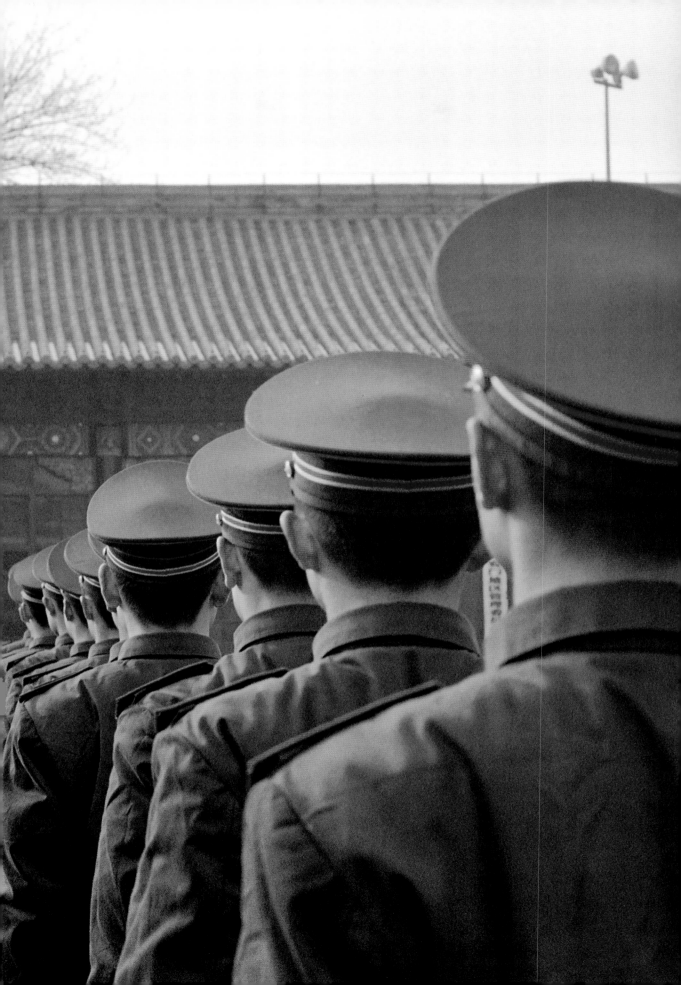

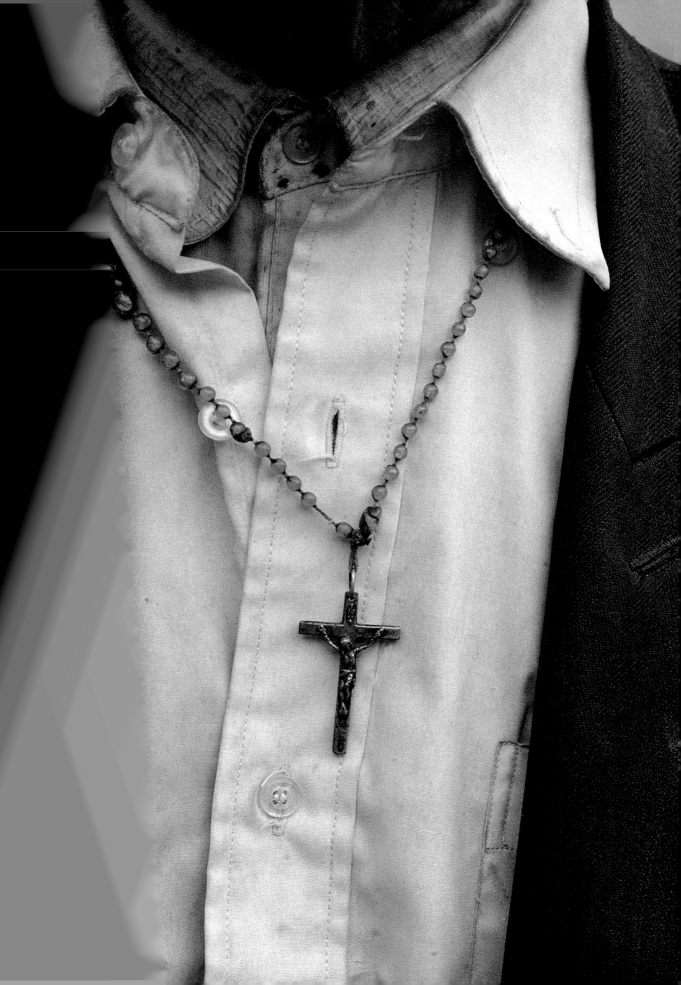

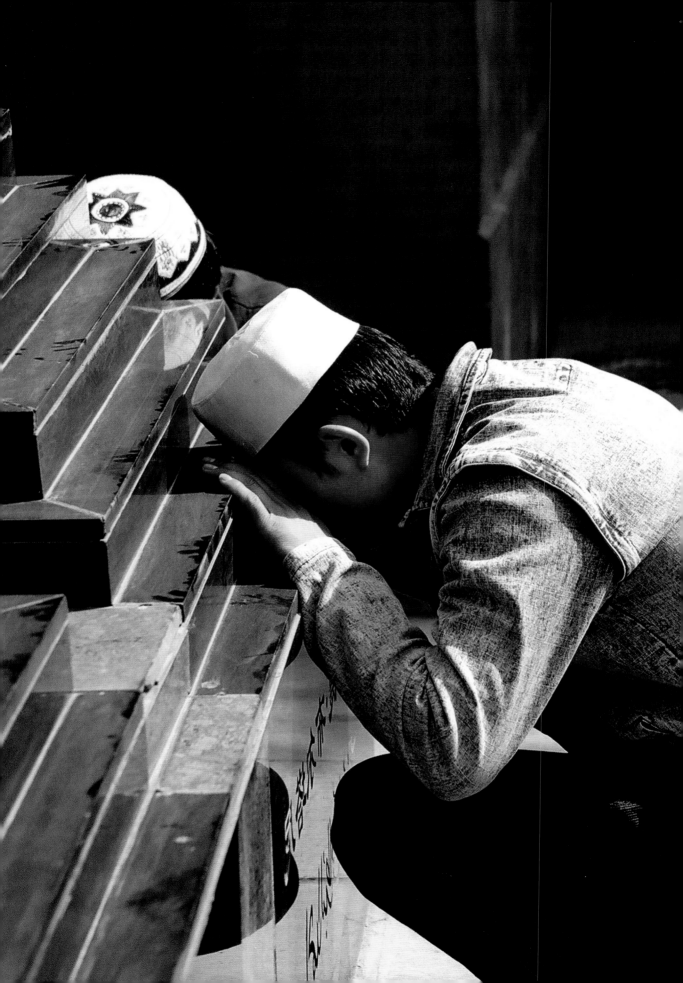

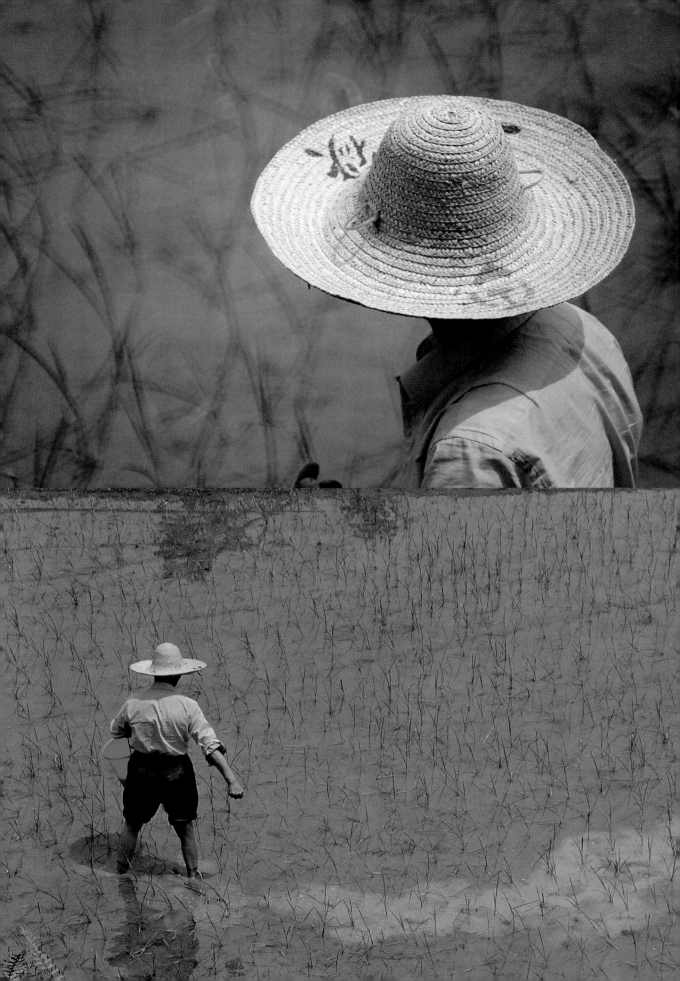

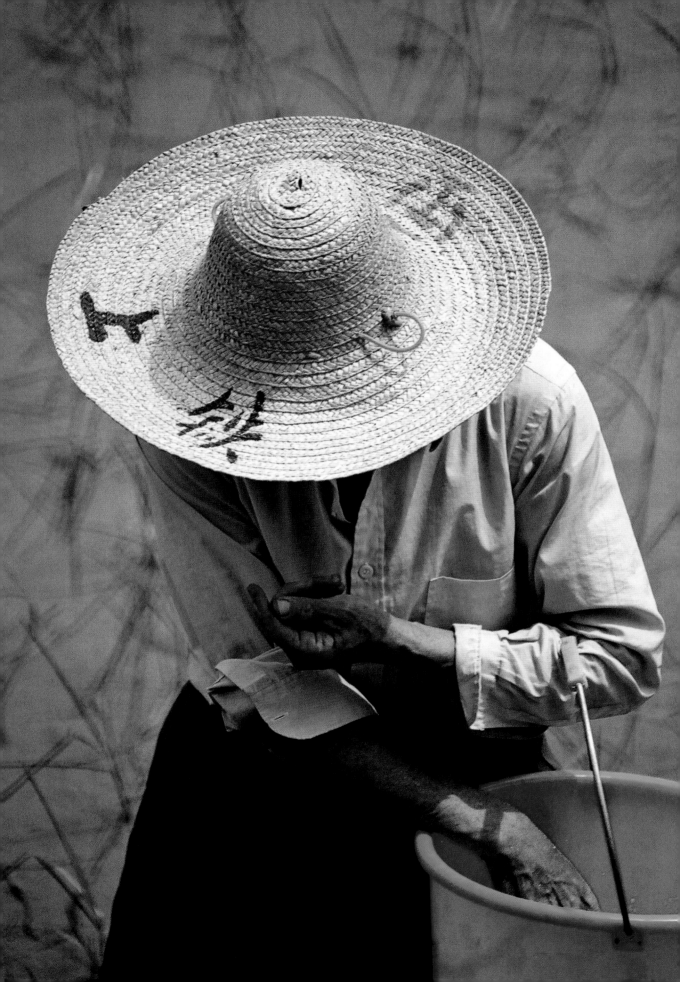

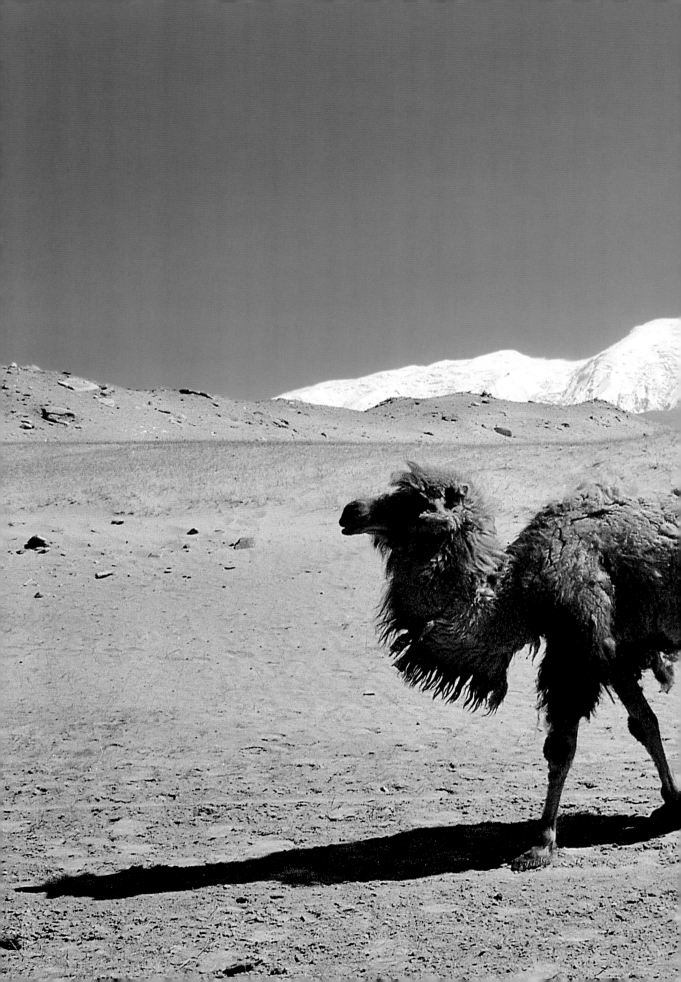

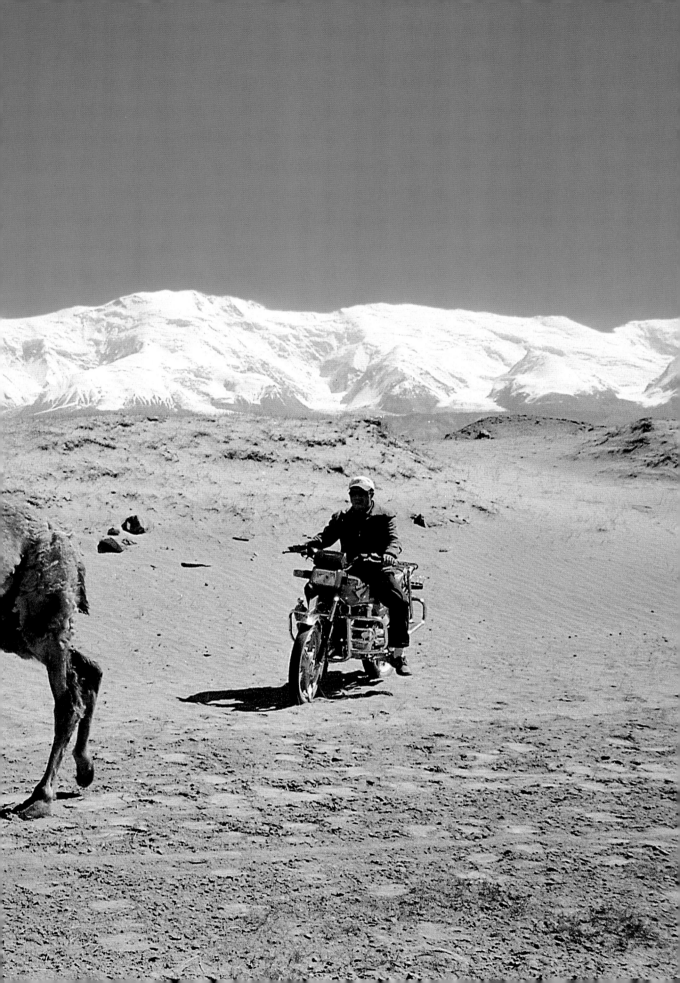

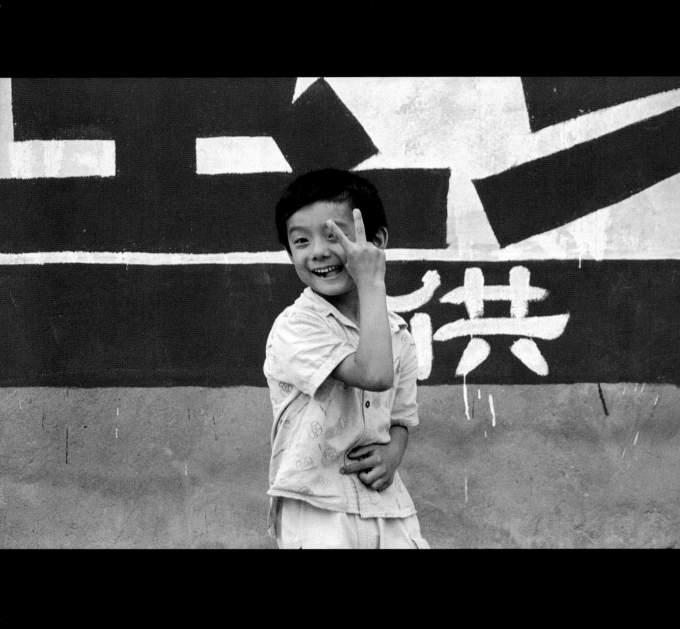

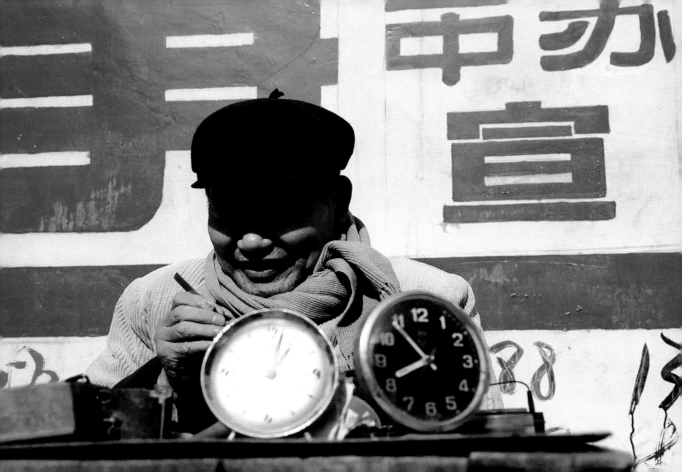

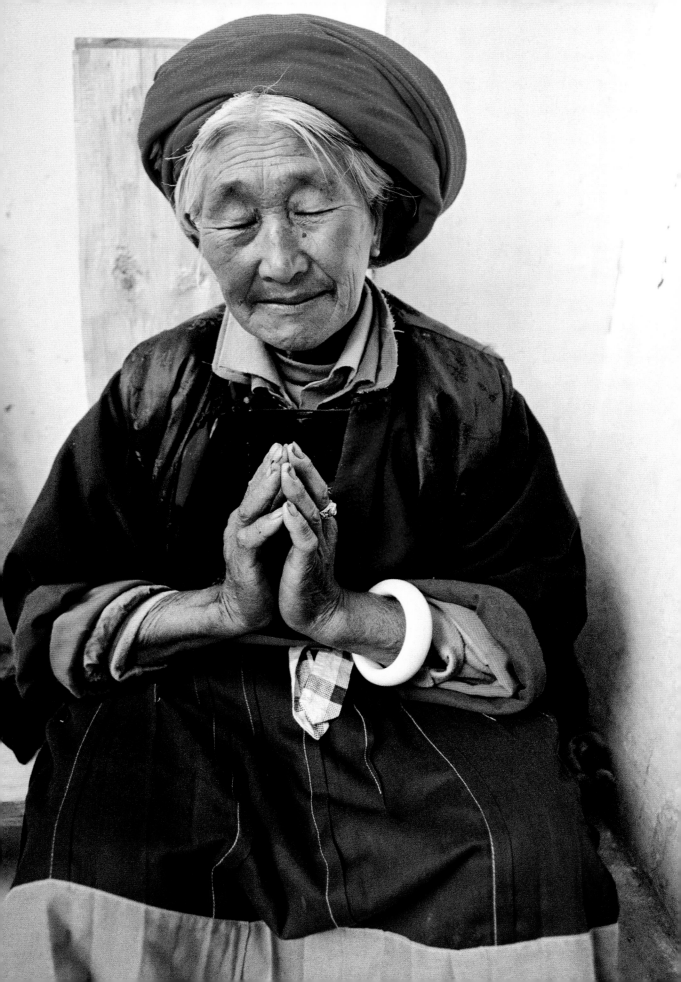

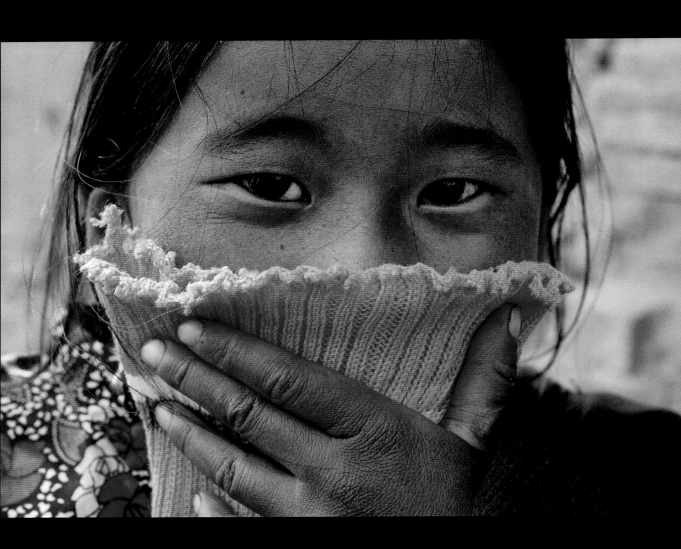

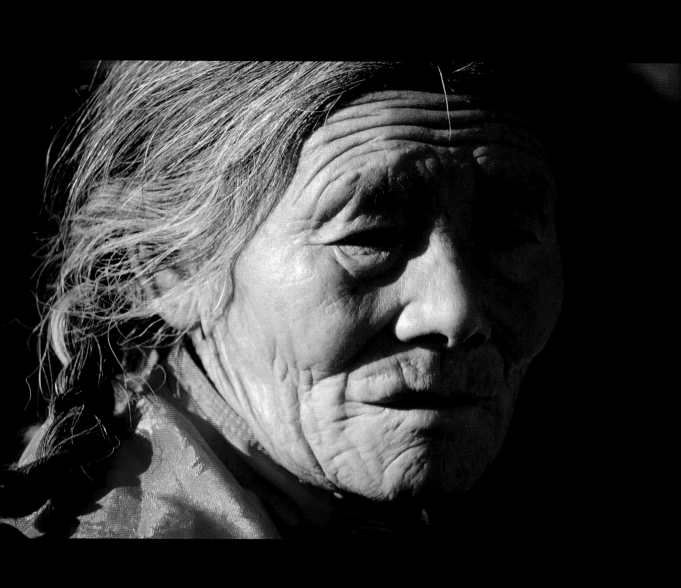

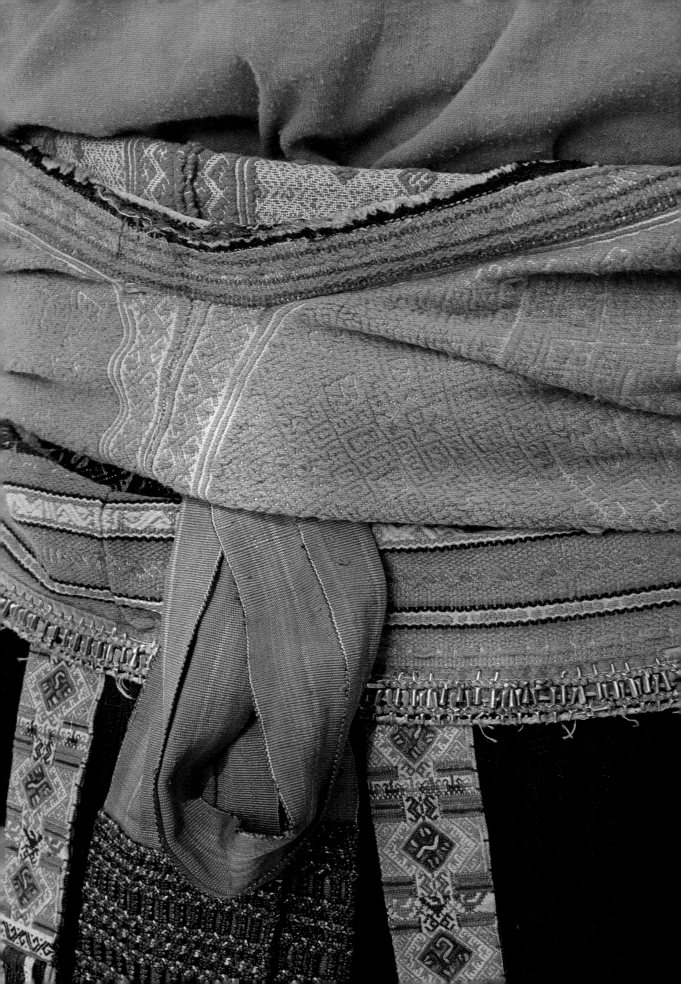

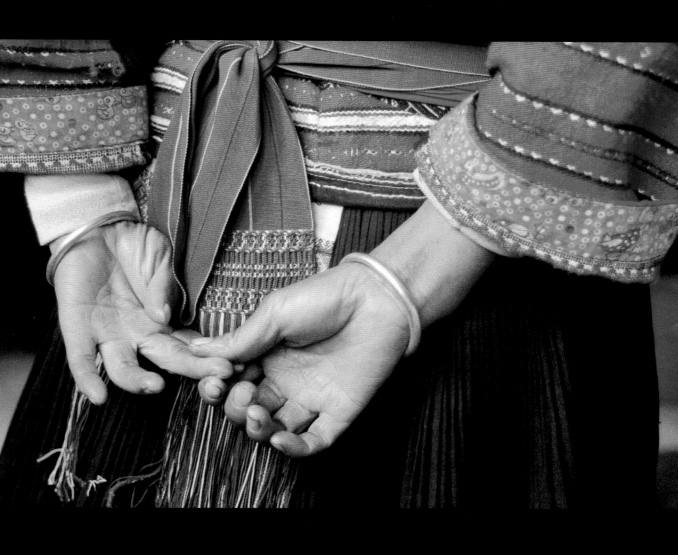

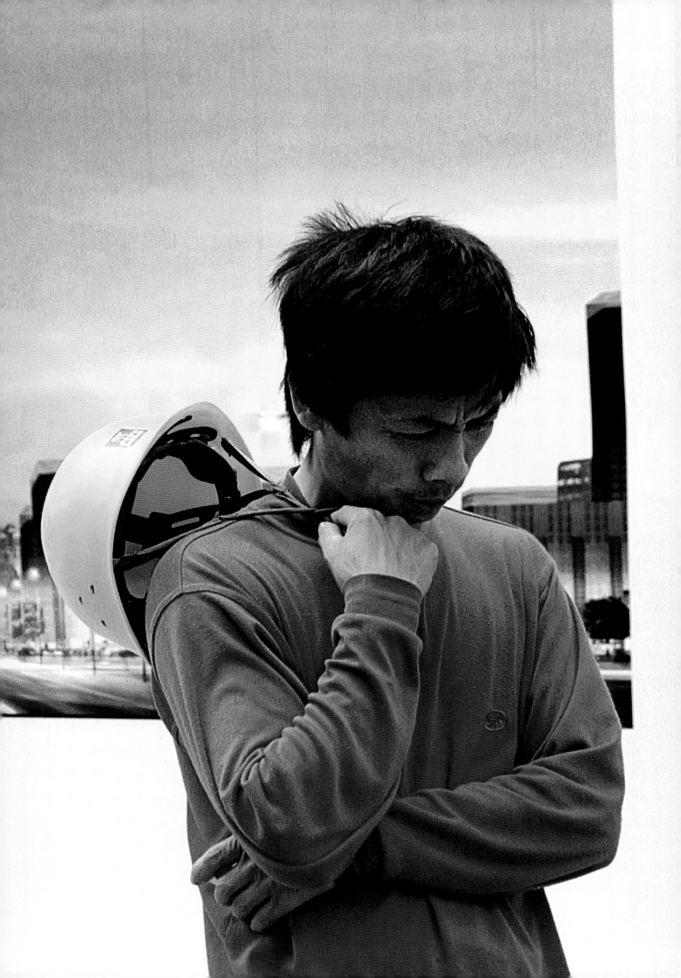

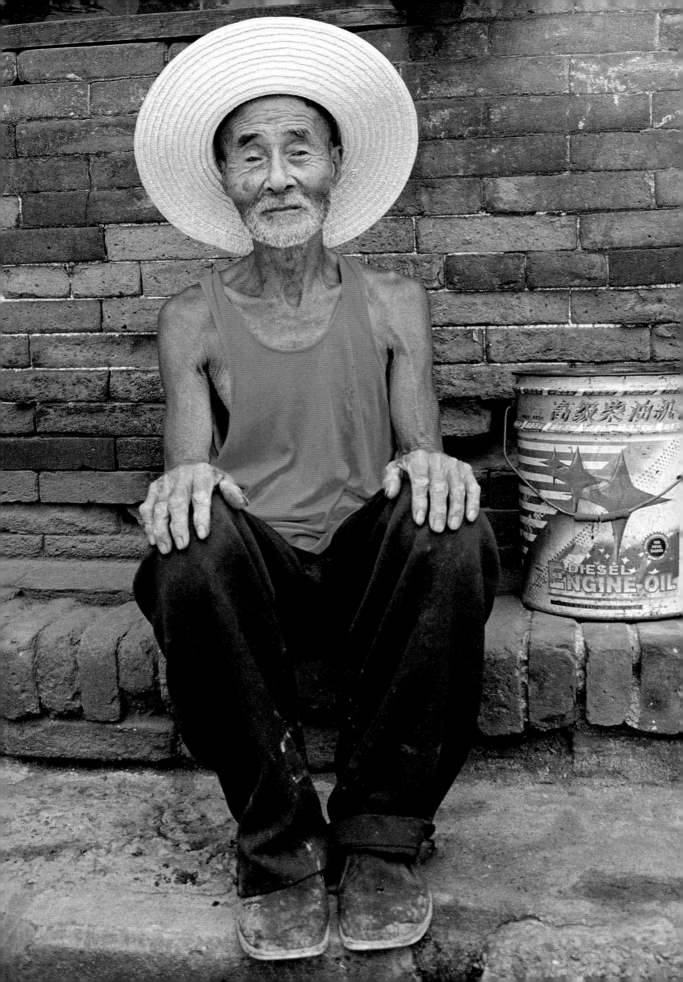

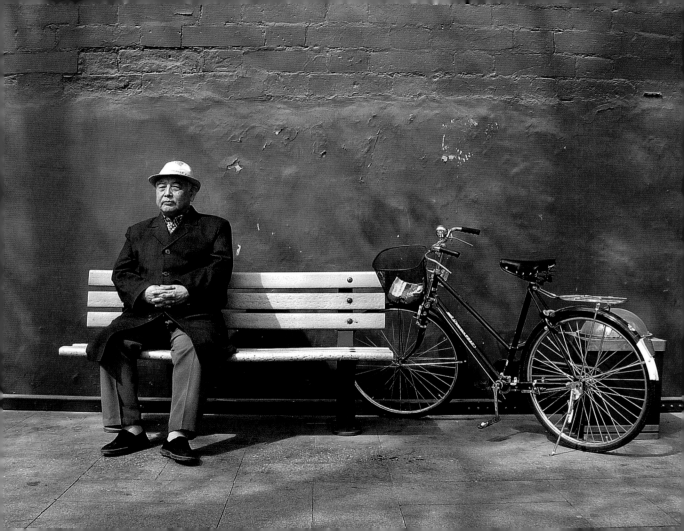

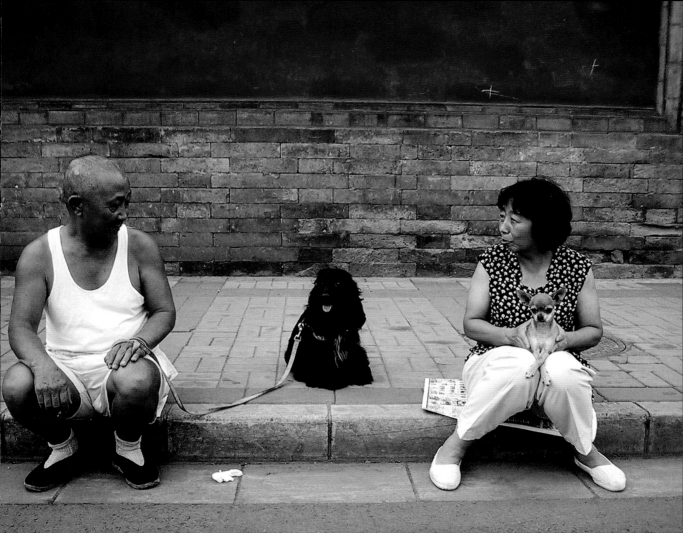

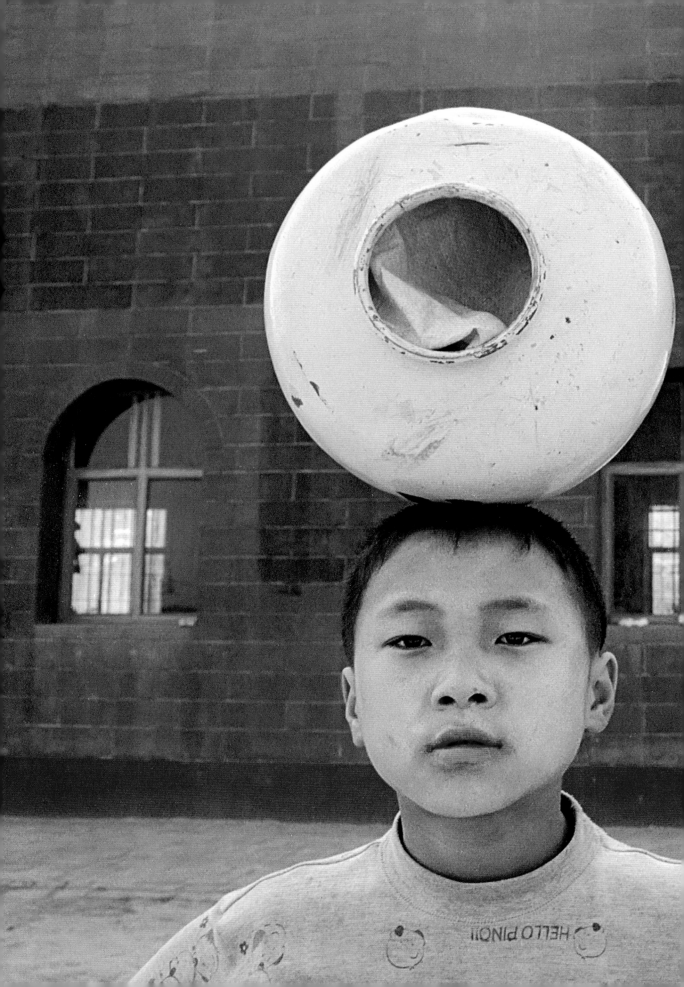

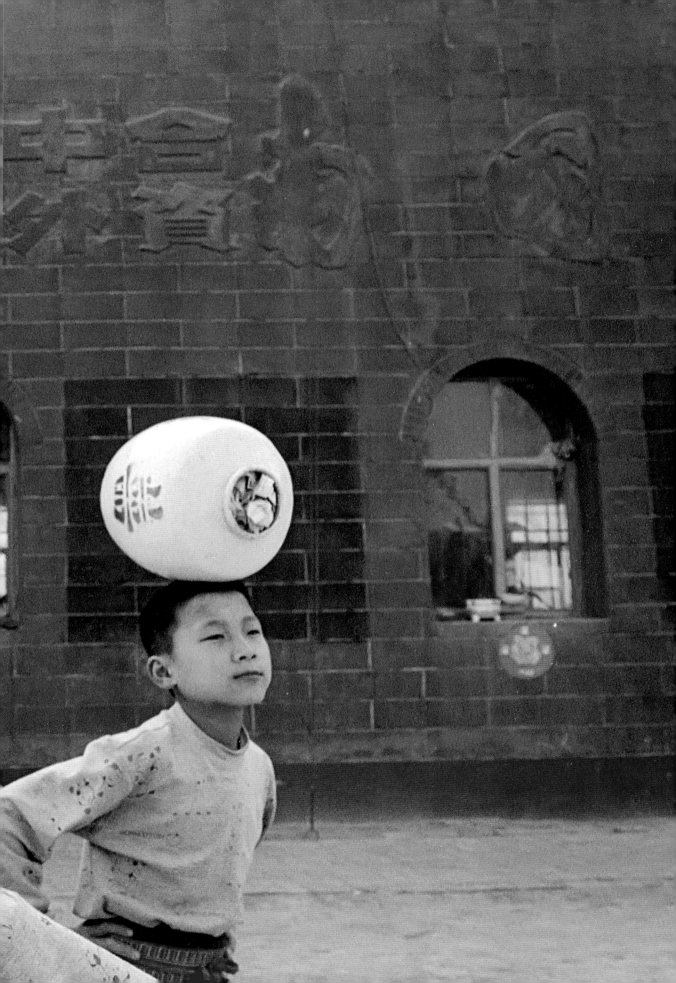

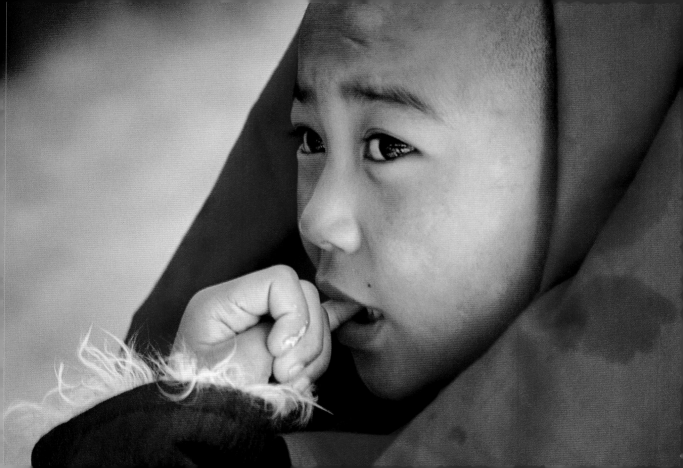

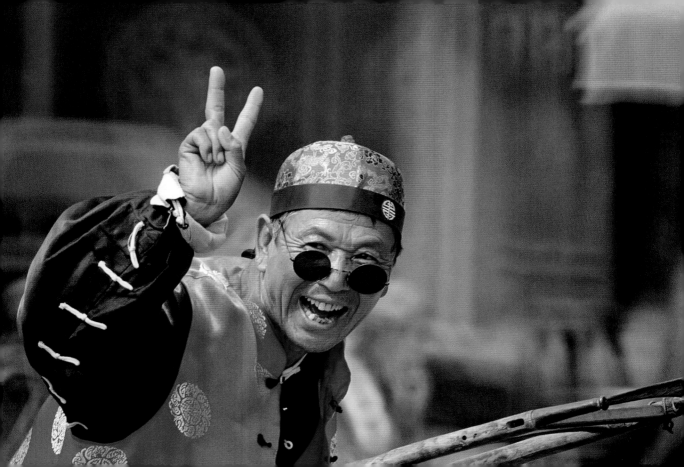

CHINESE

中国物品

THINGS

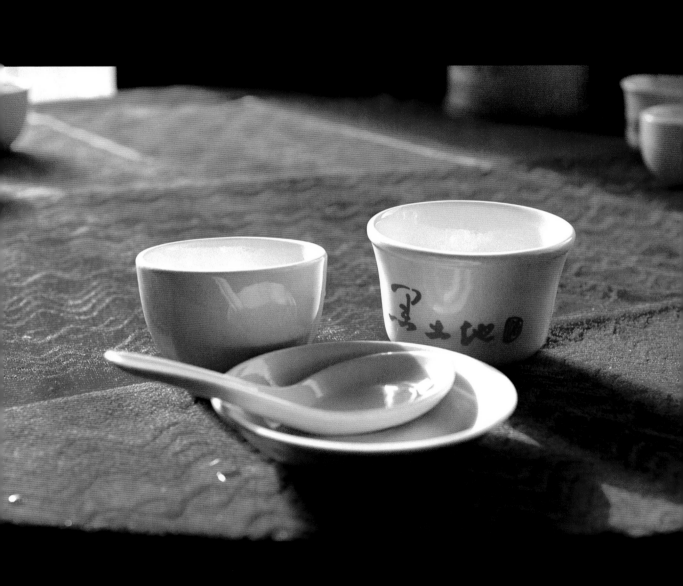

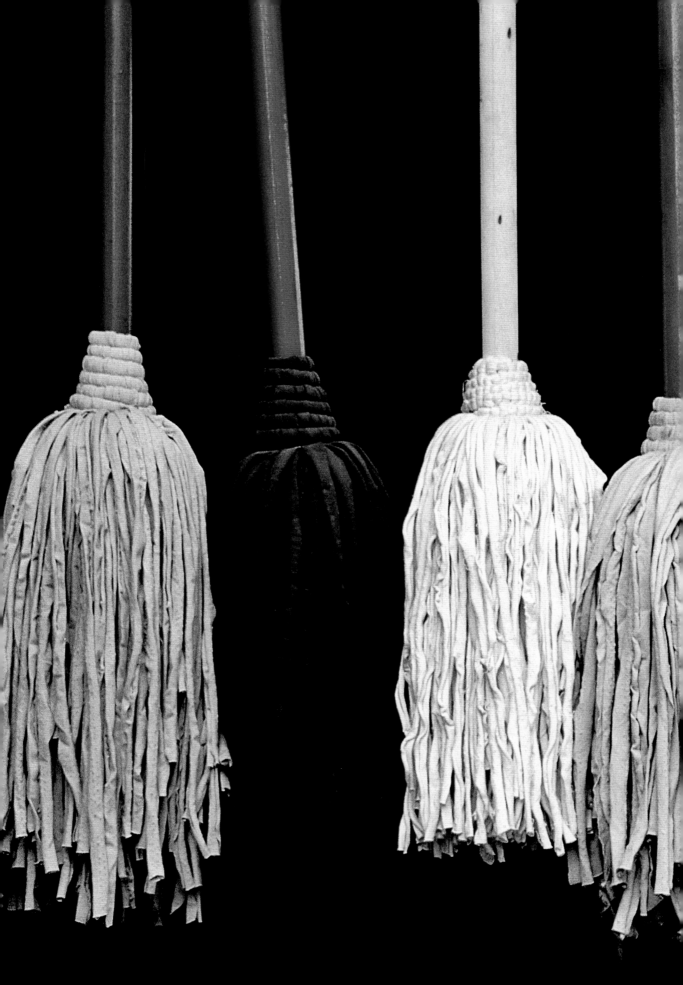

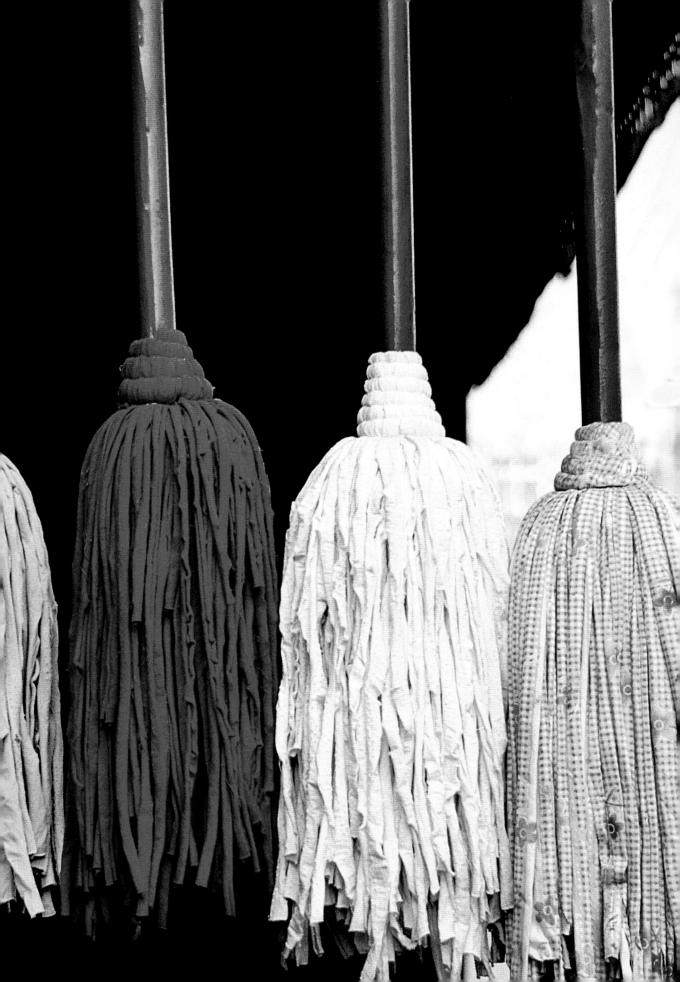

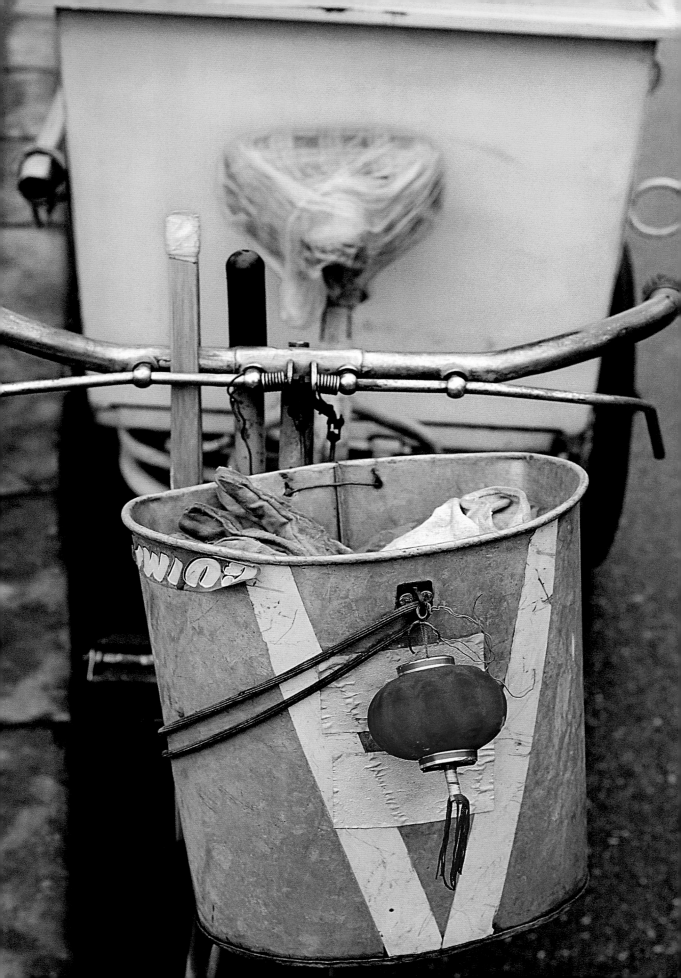

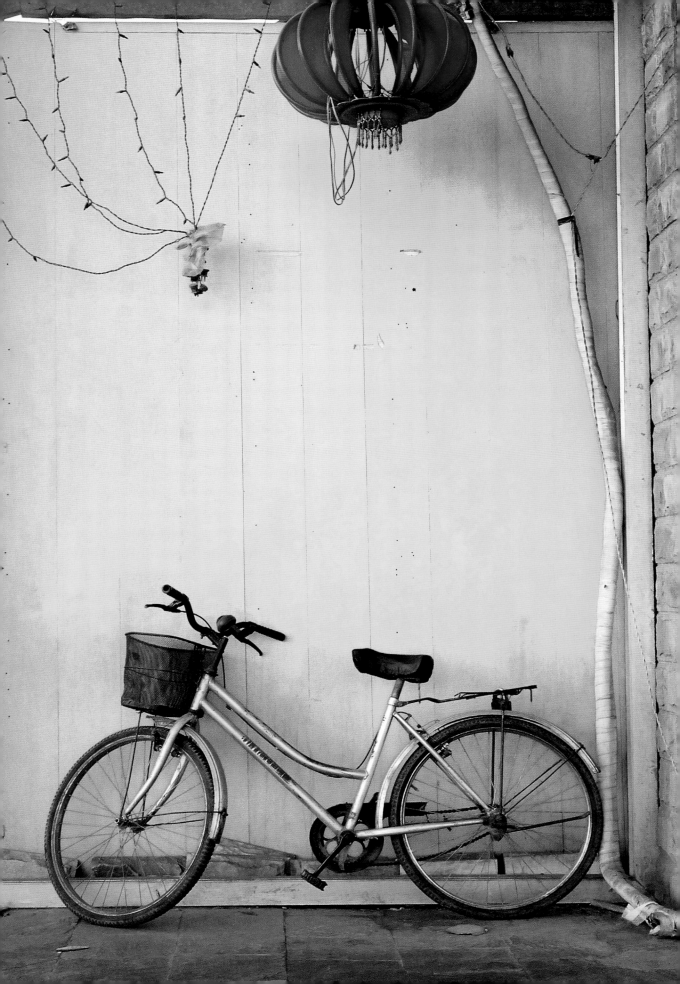

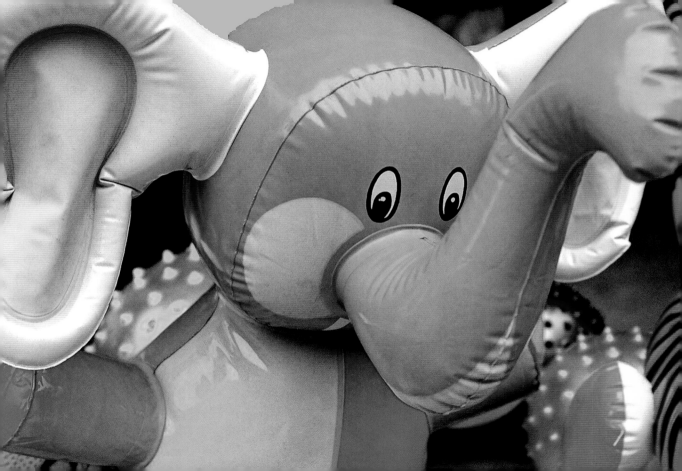

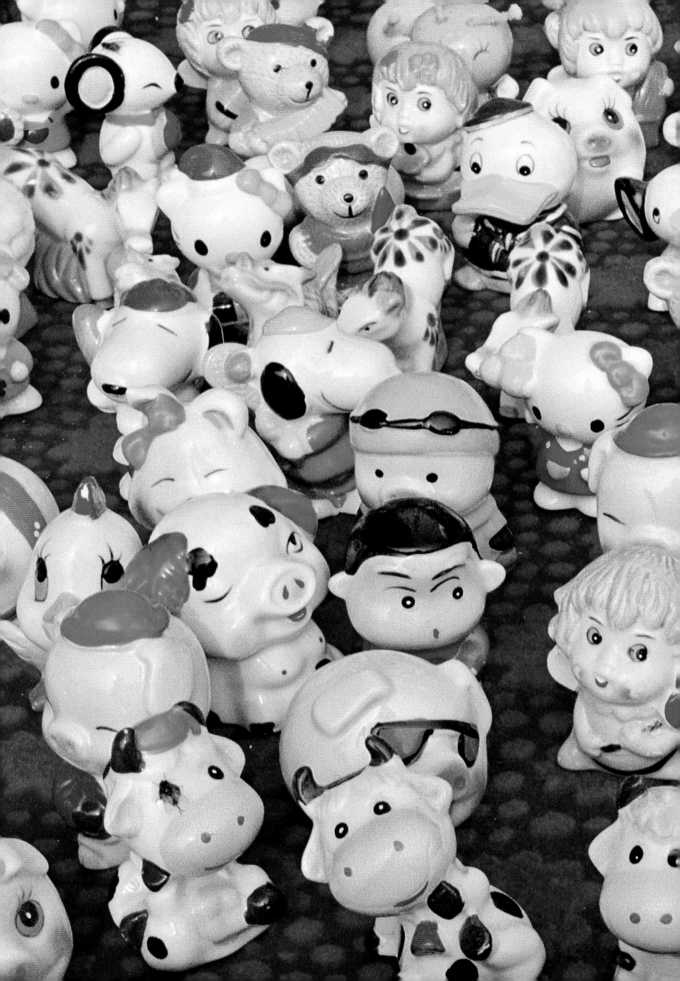

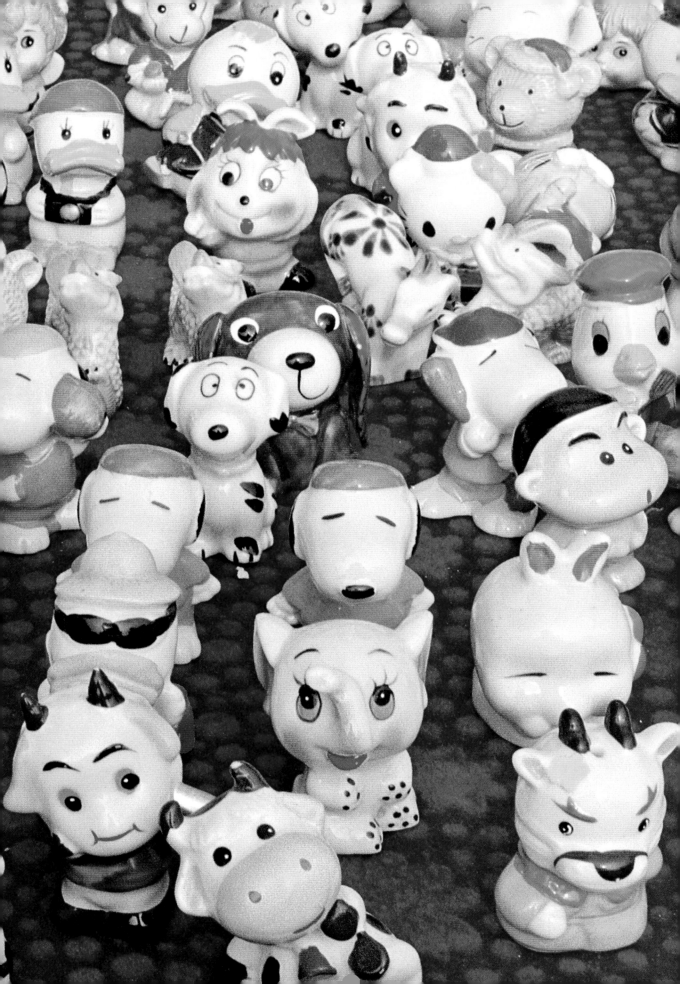

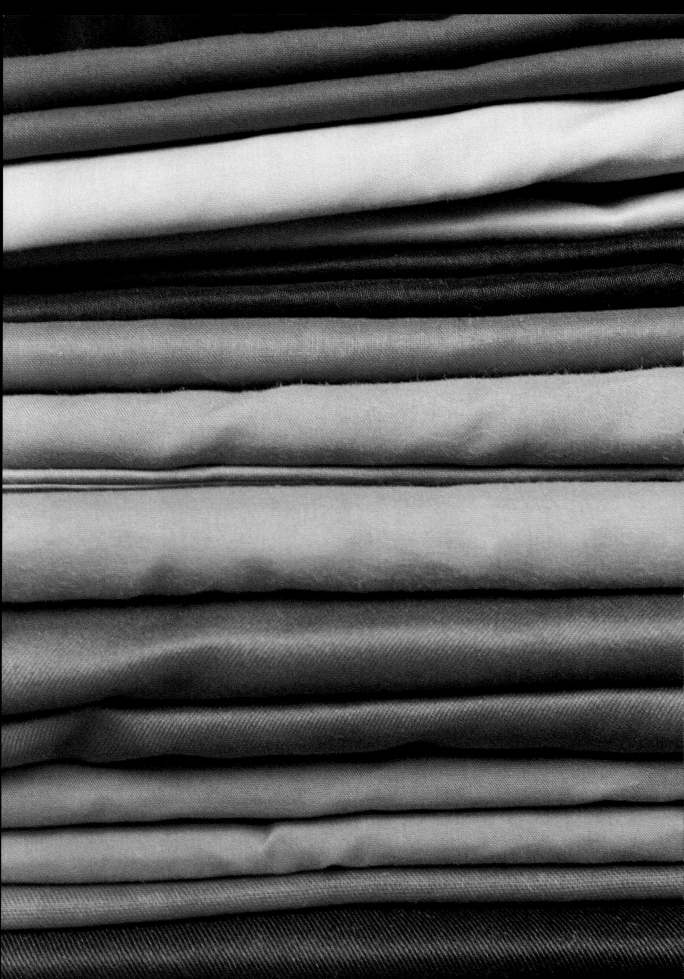

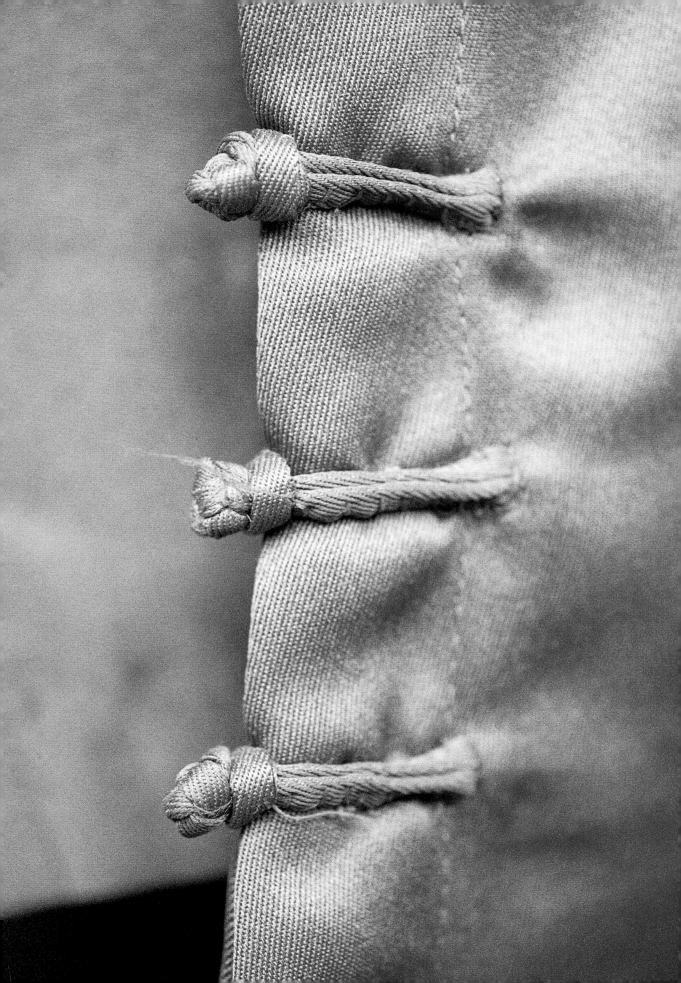

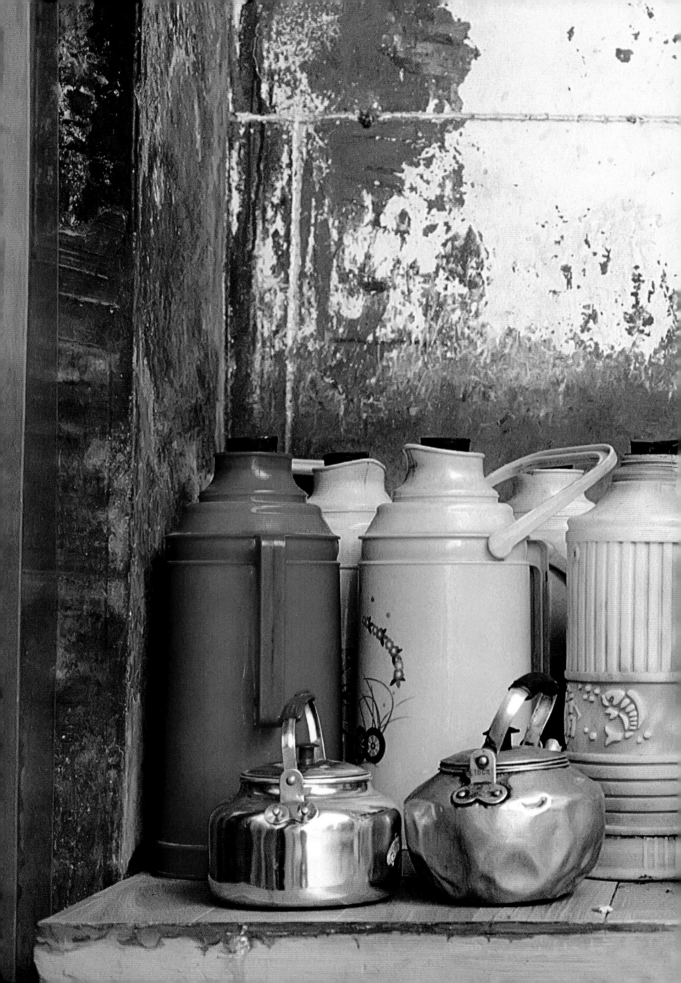

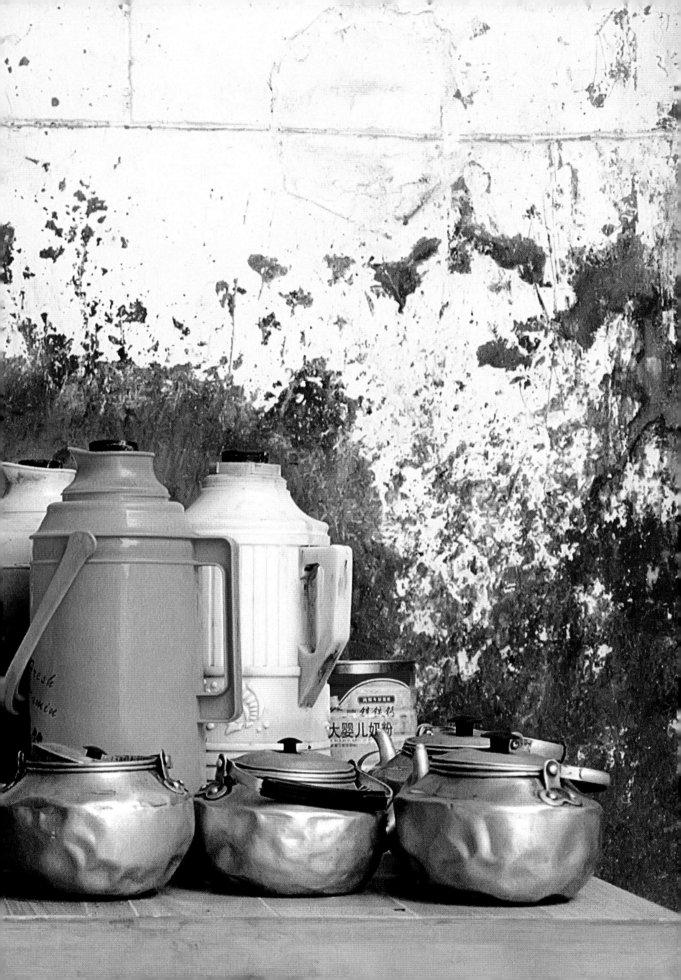

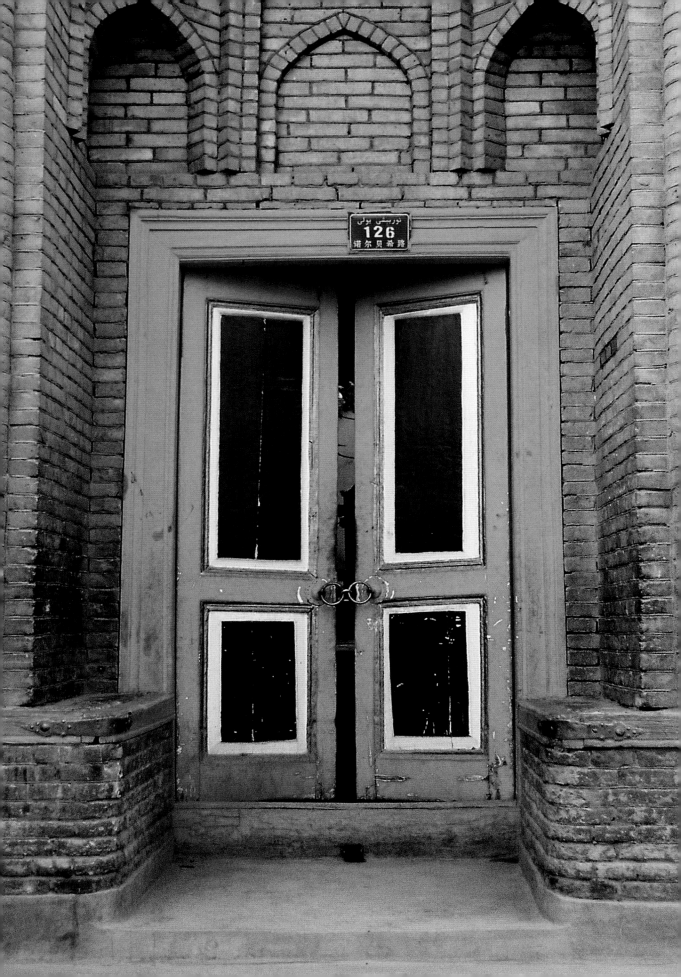

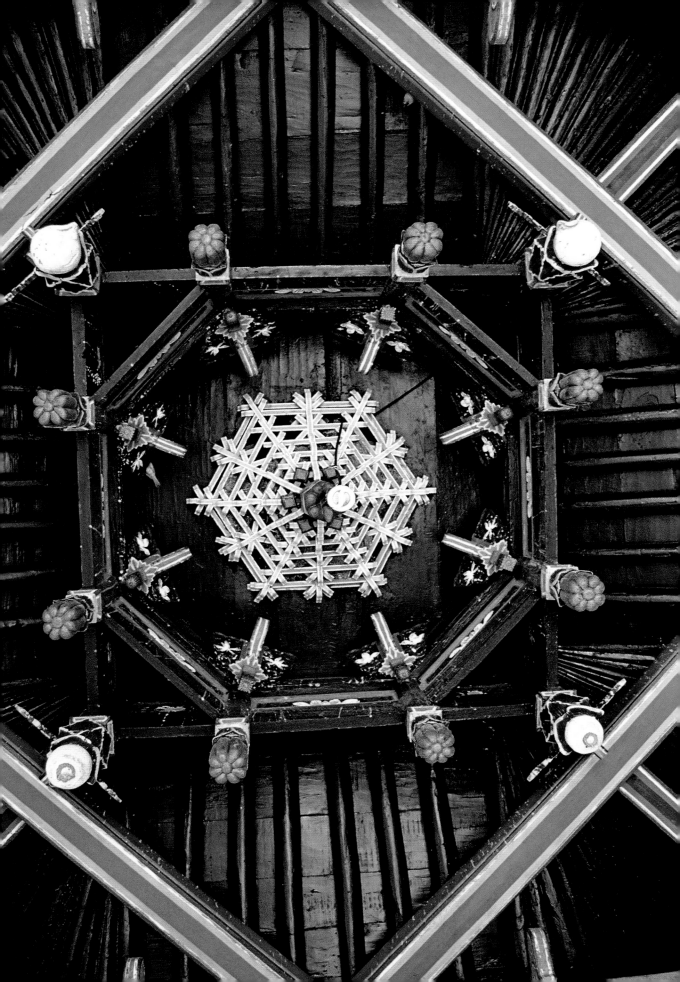

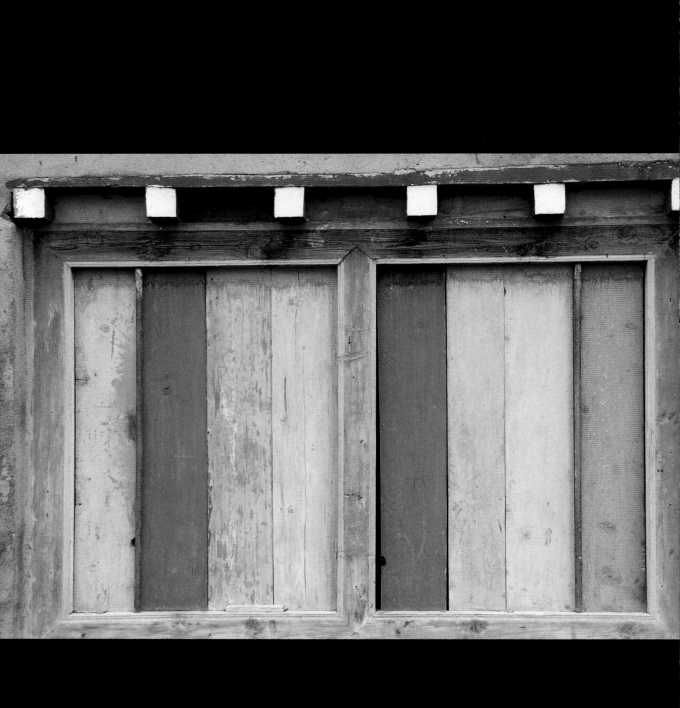

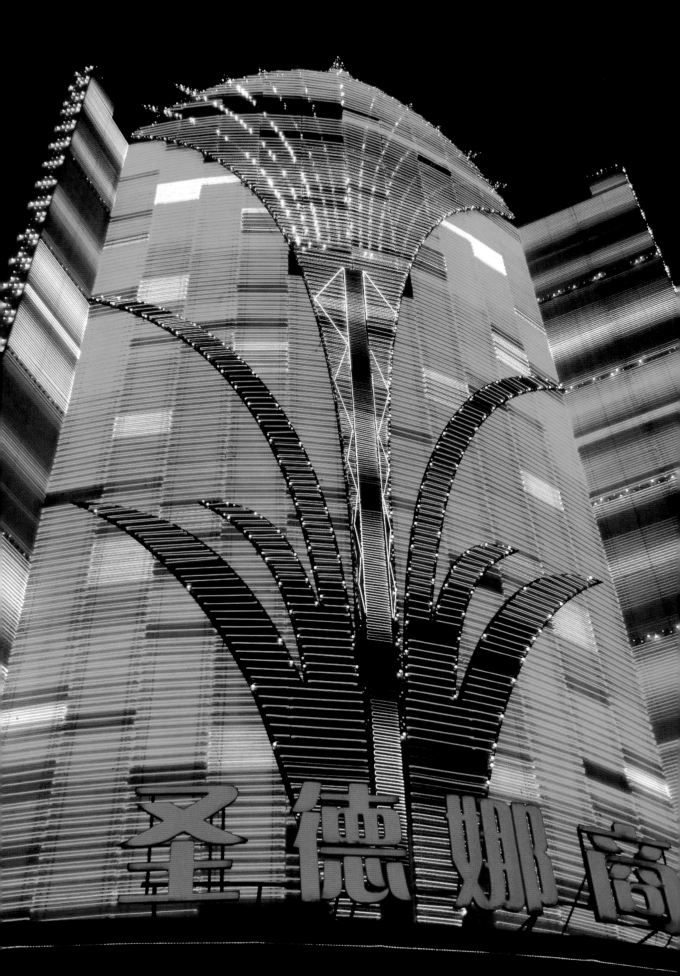

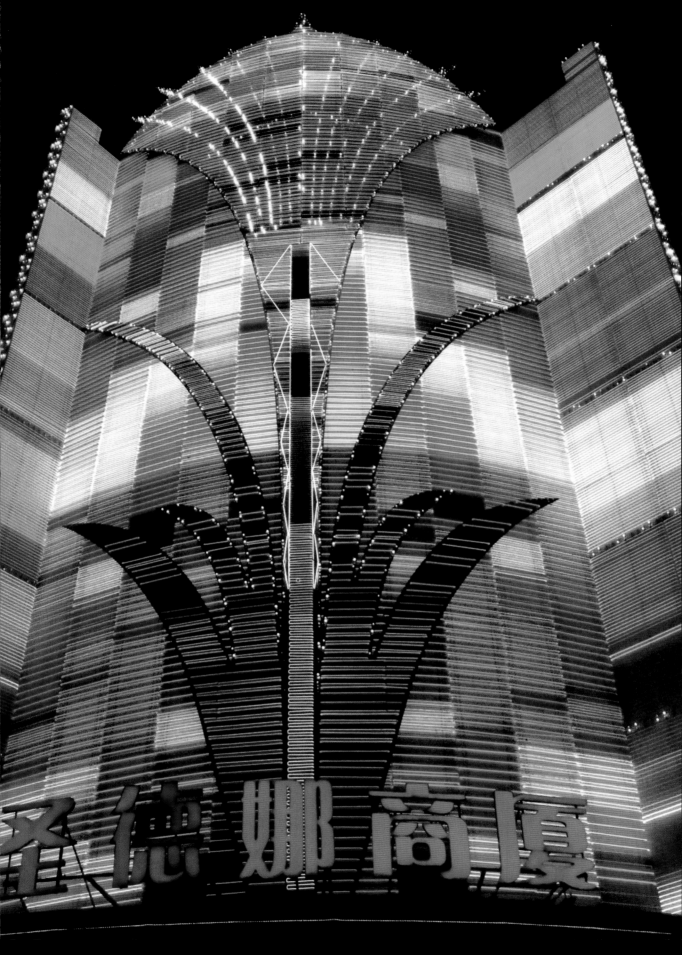

圣德娜商厦

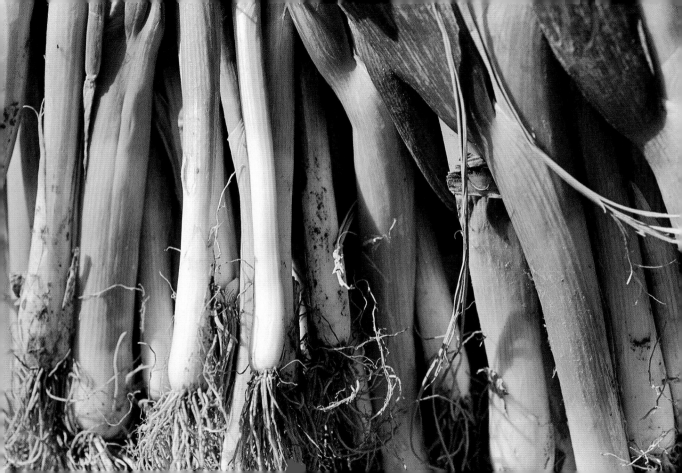

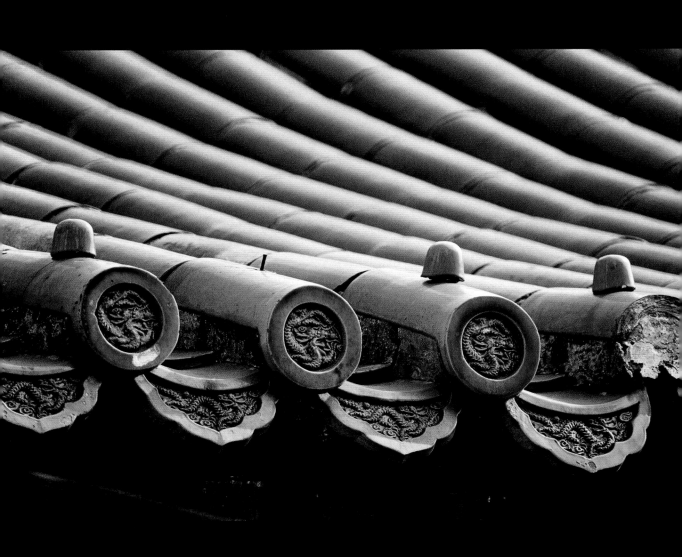

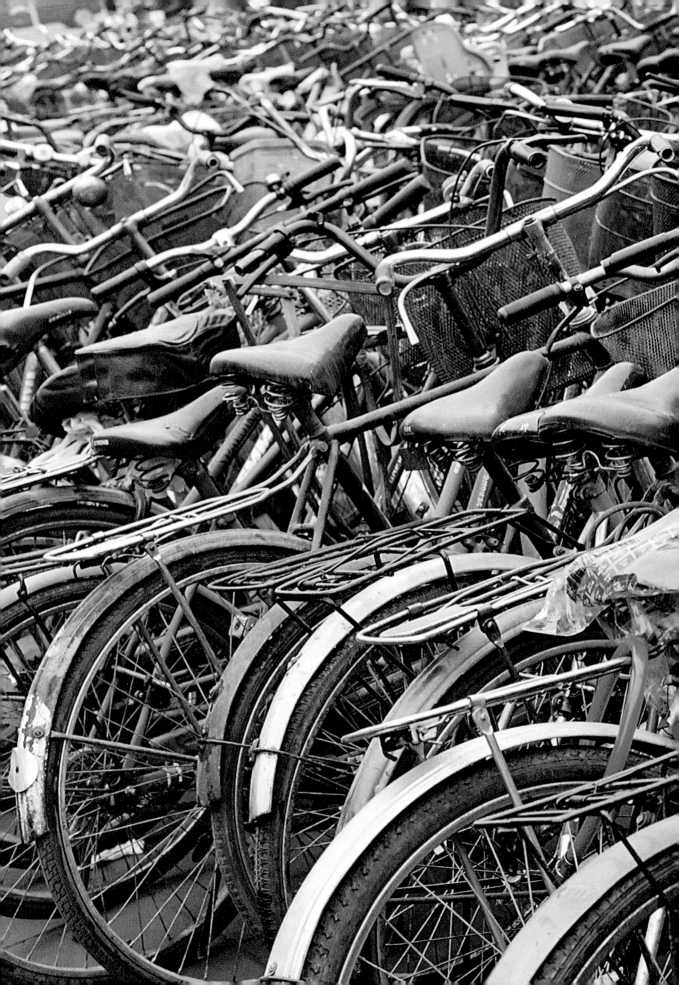

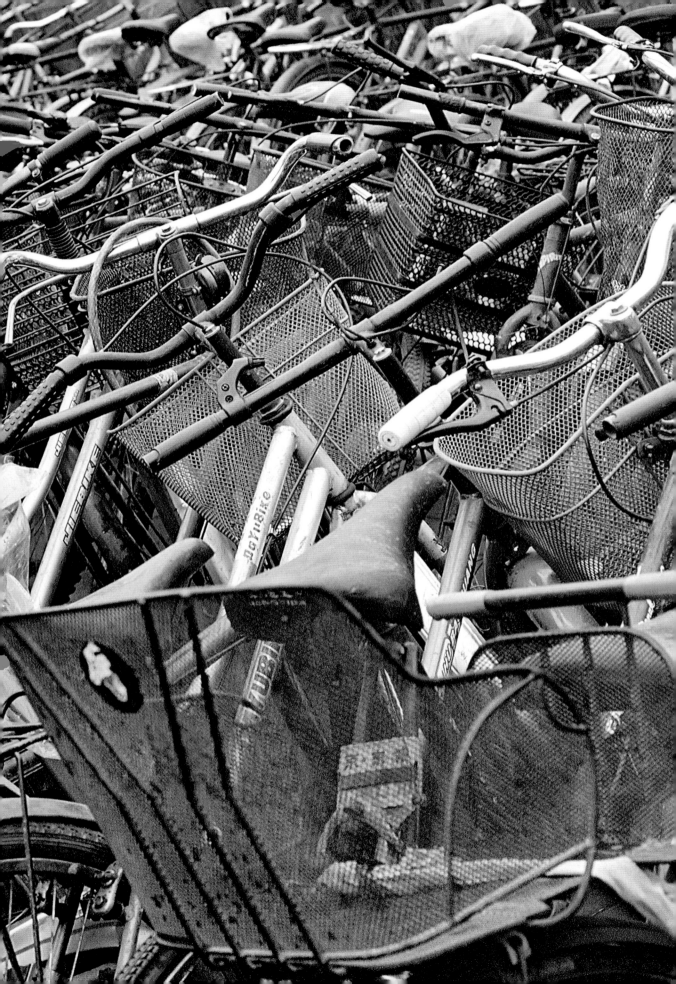

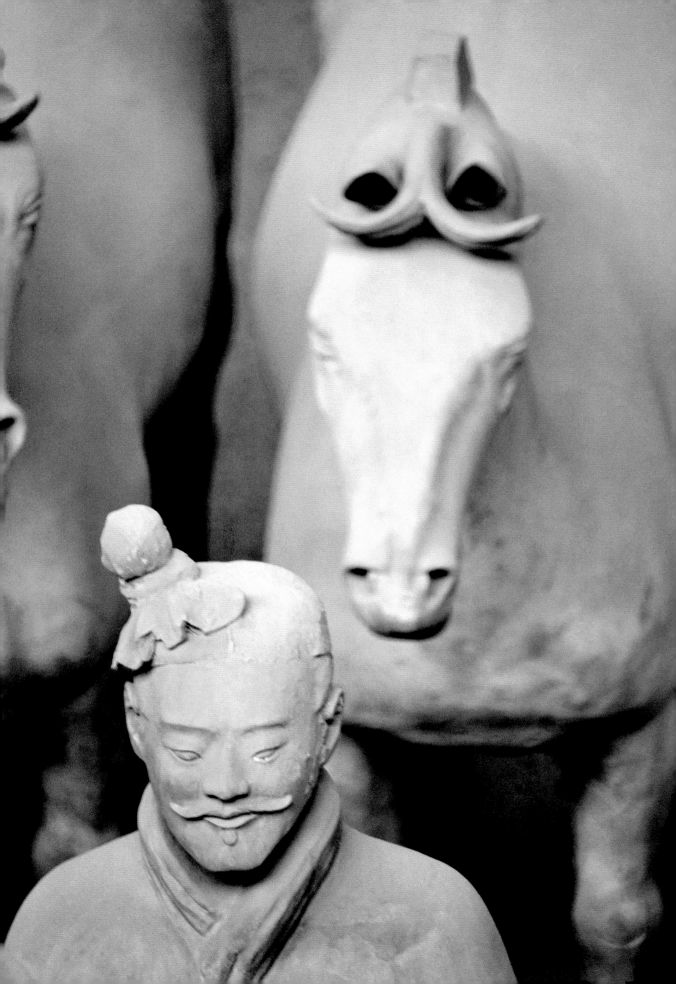

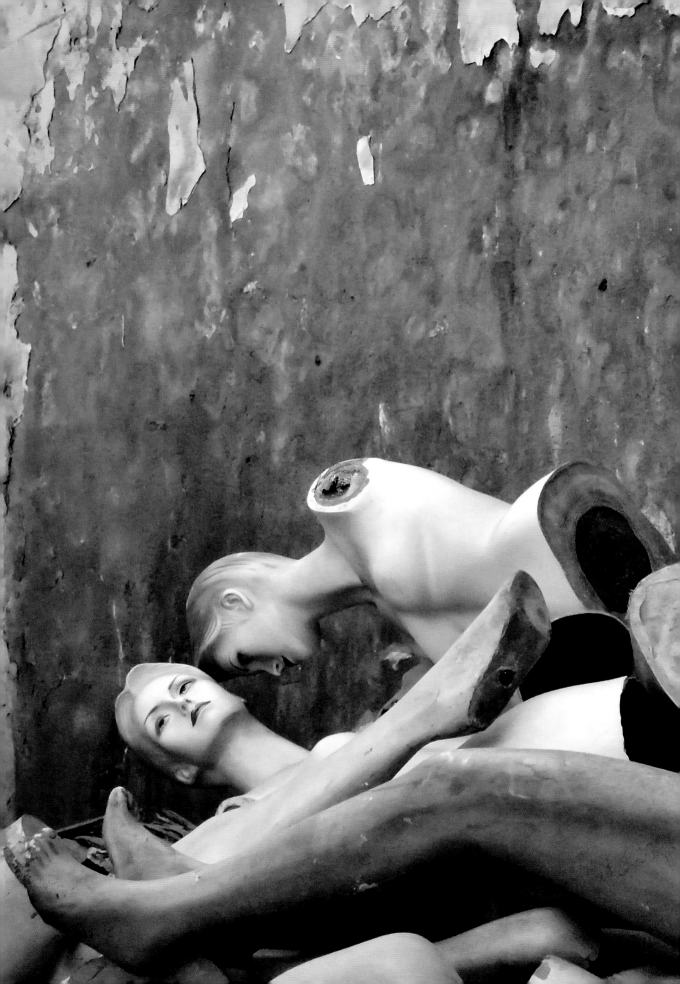

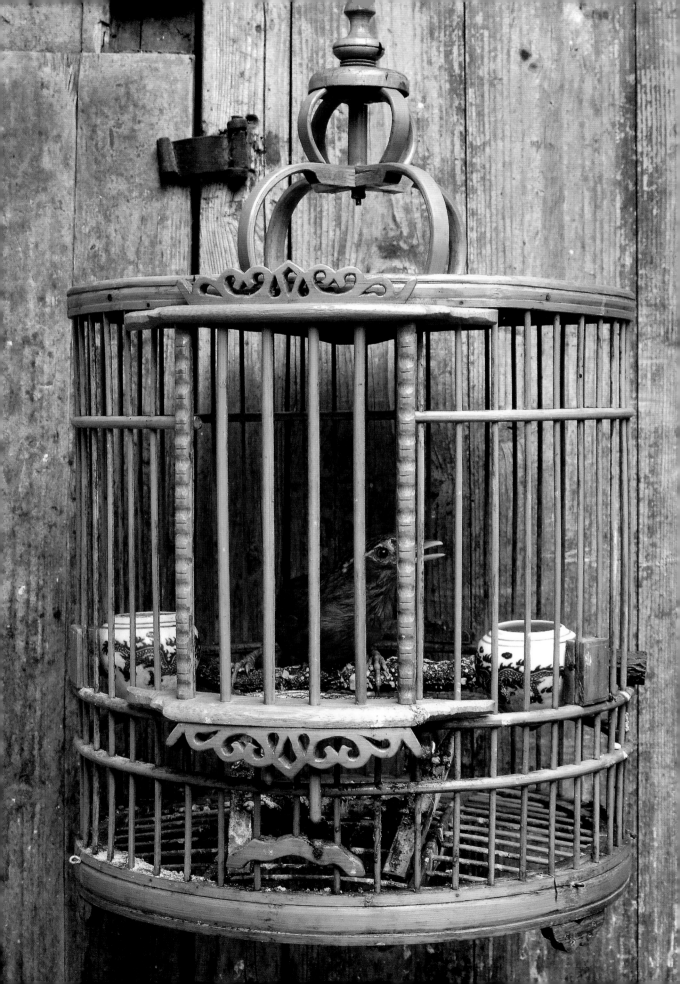

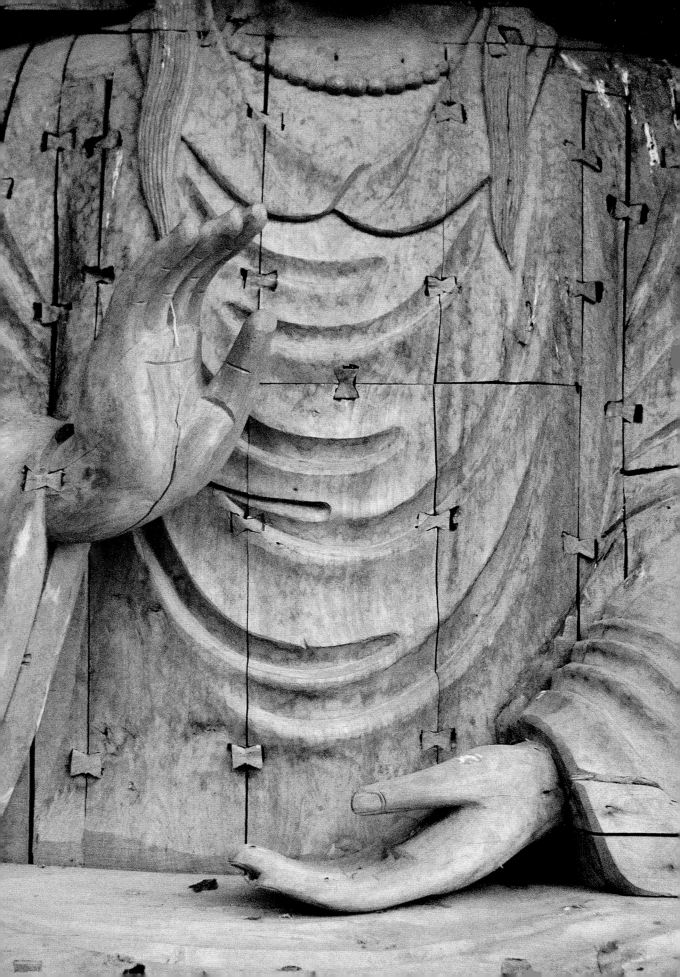

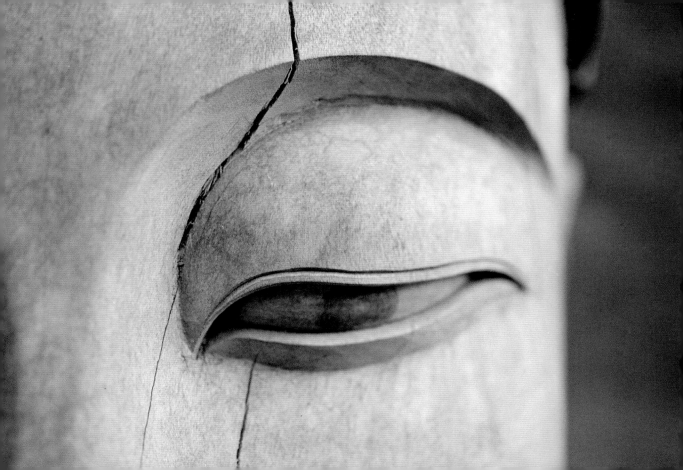

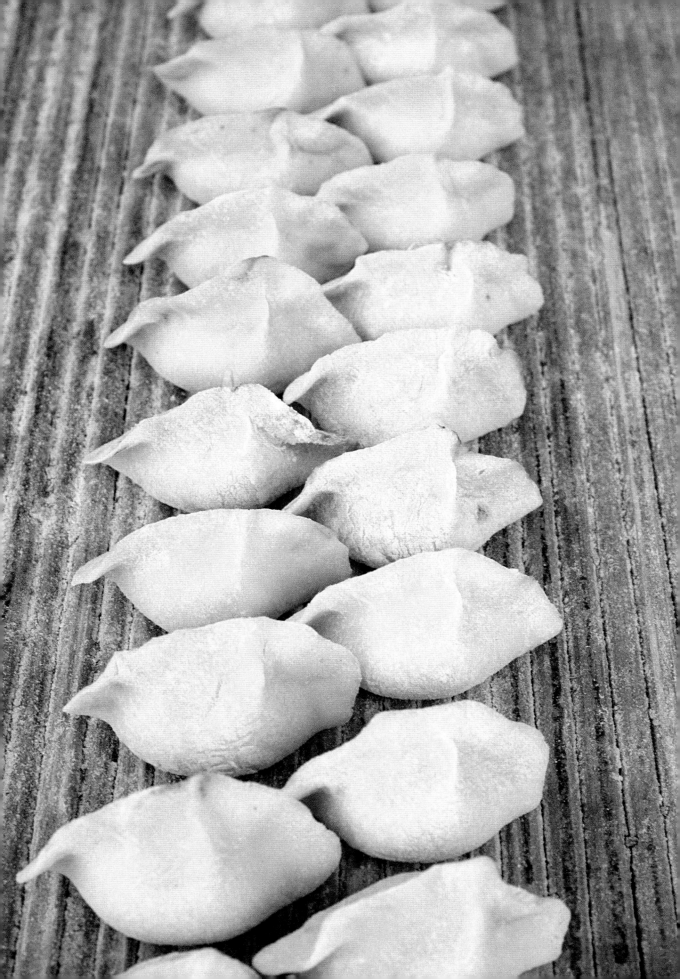

CHINESE

中国风景

PLACES

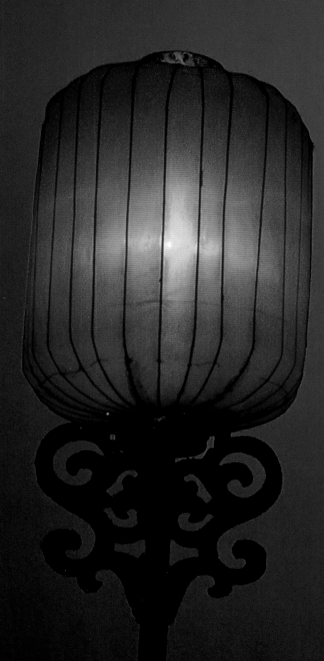

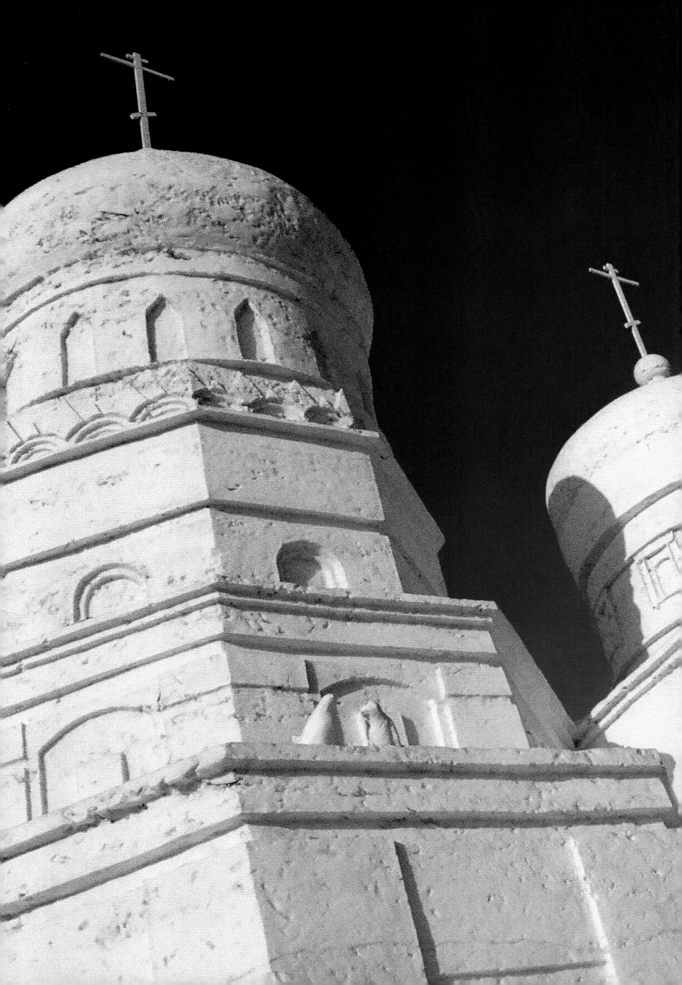

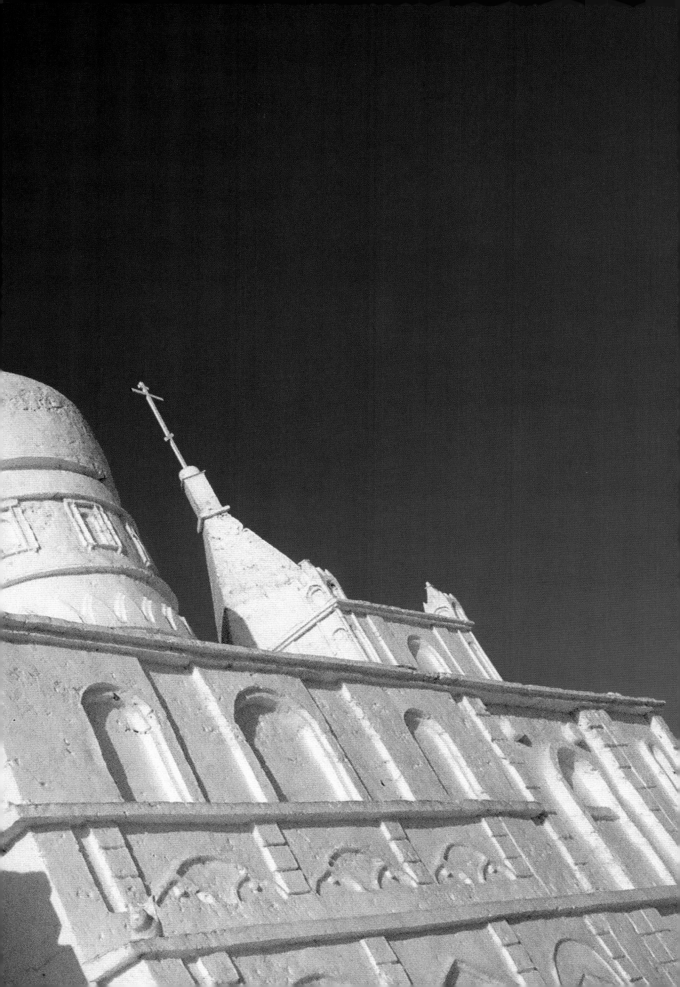

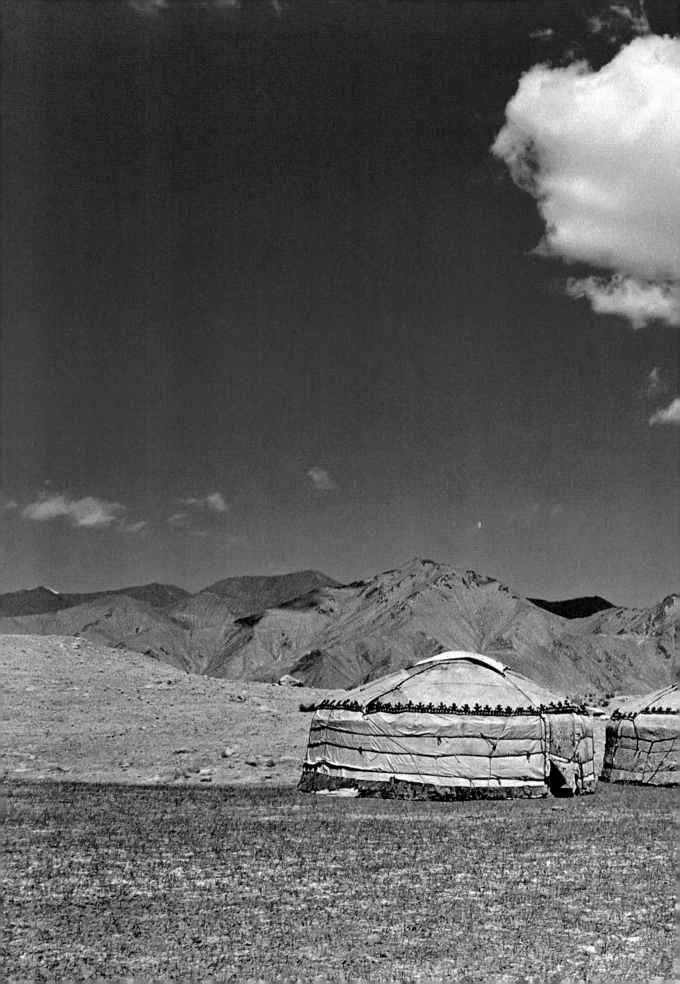

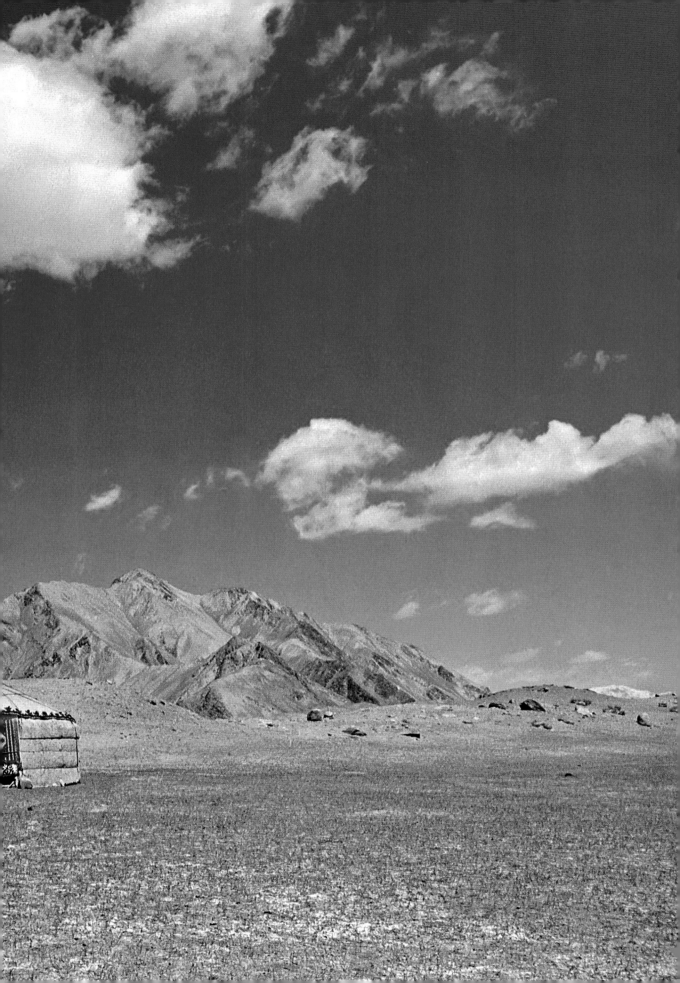

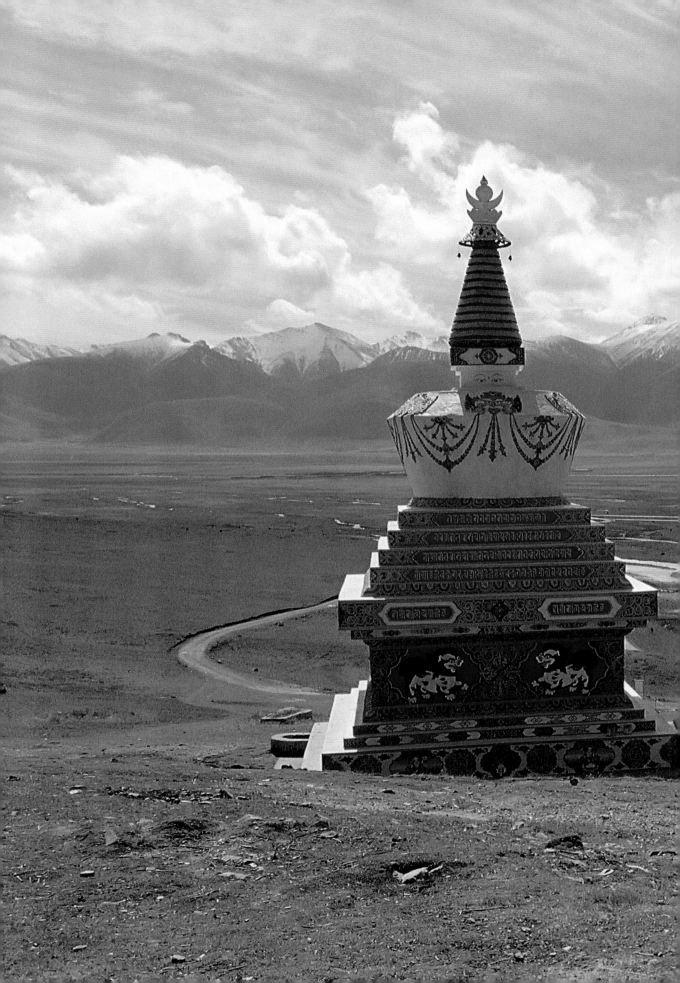

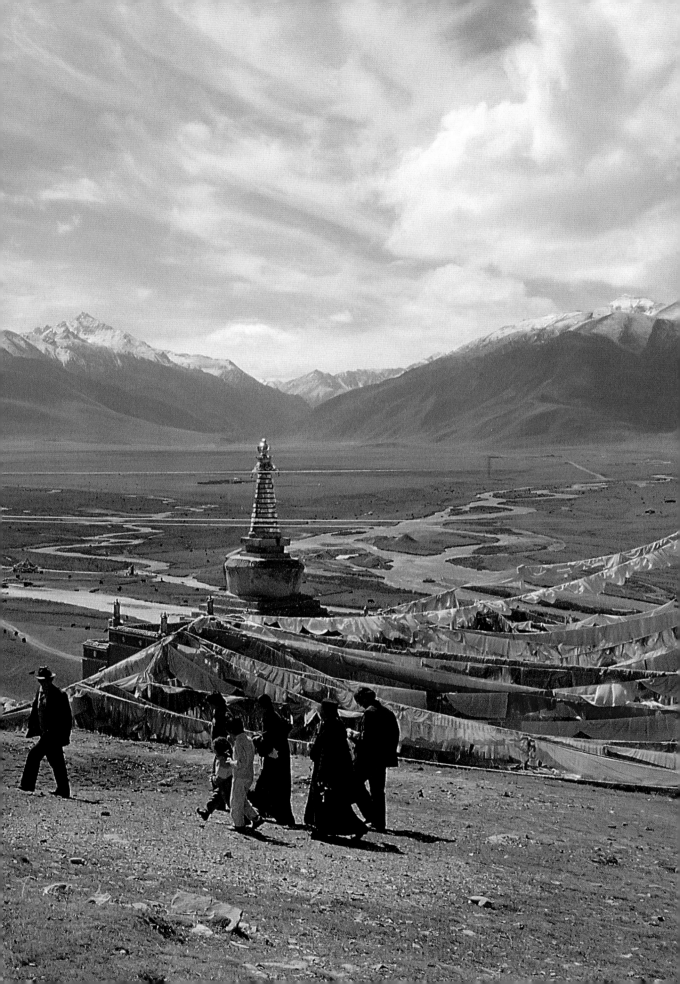

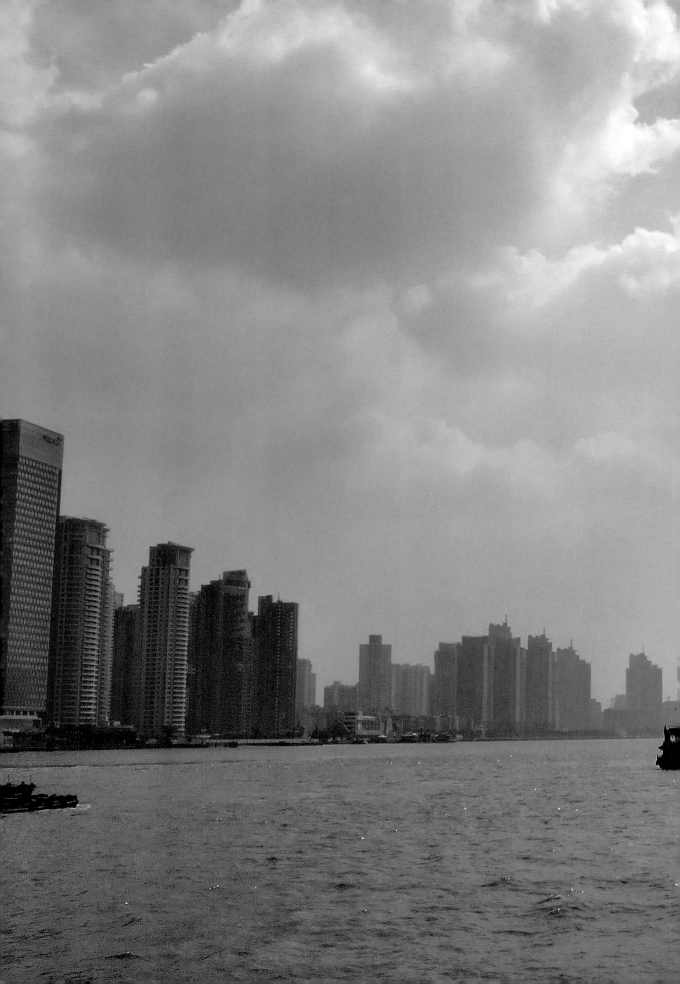

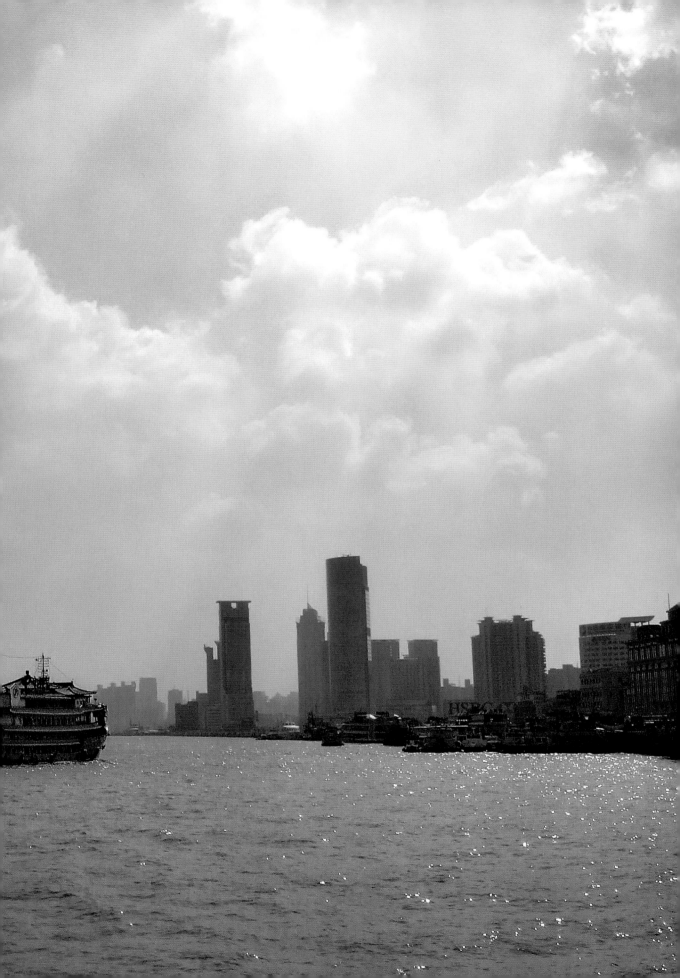

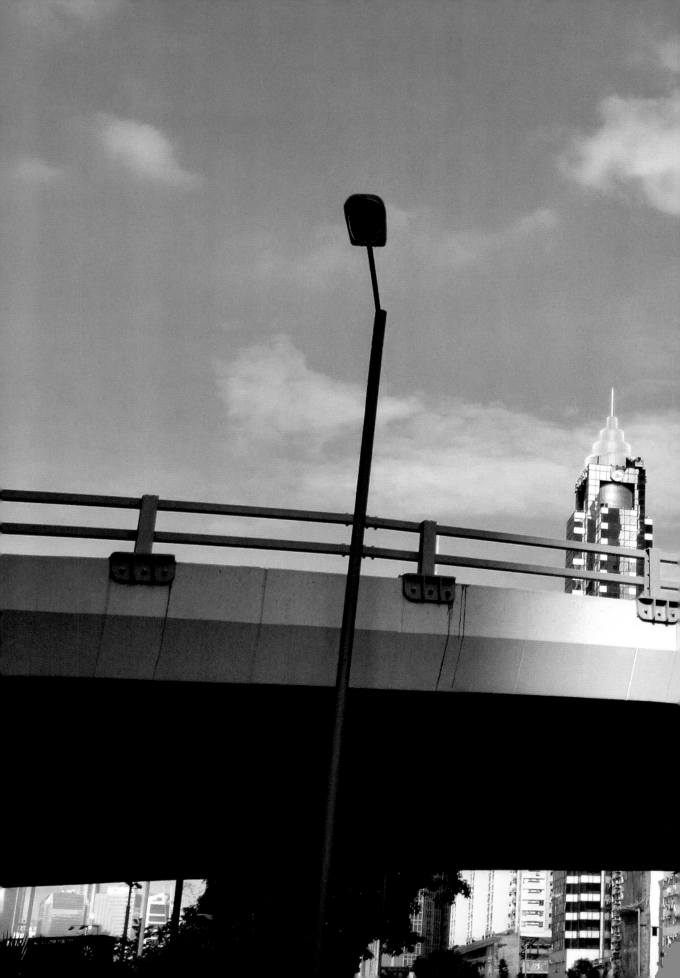

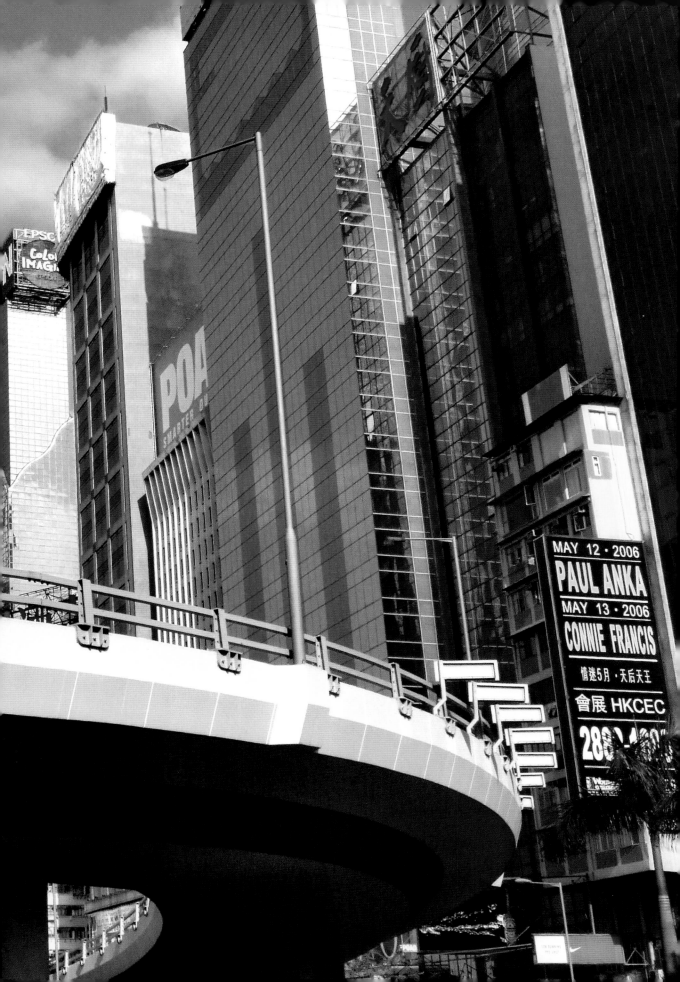

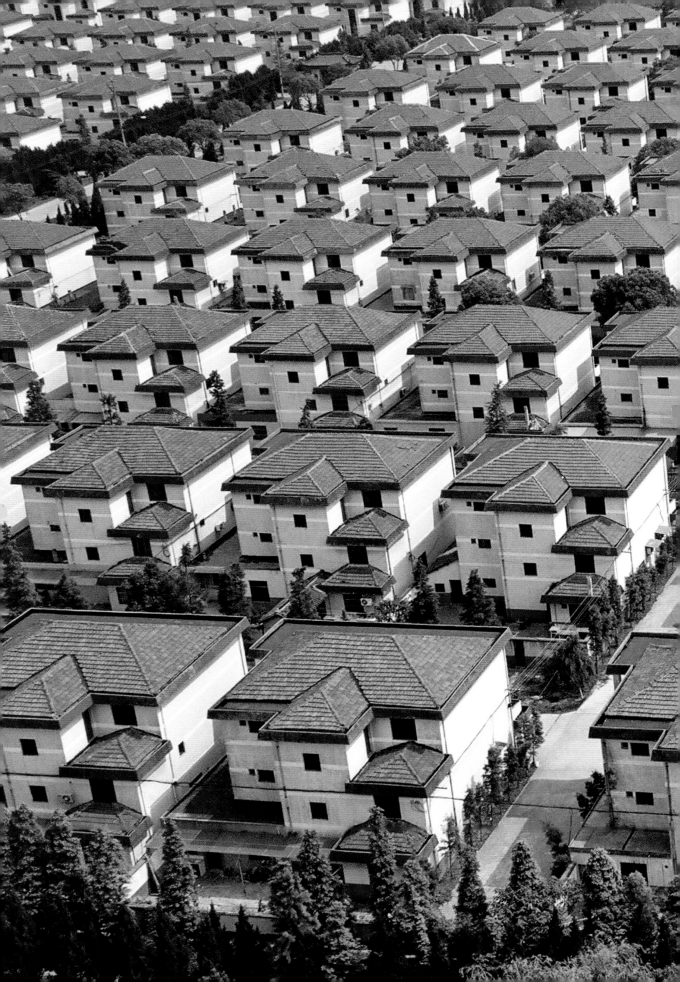

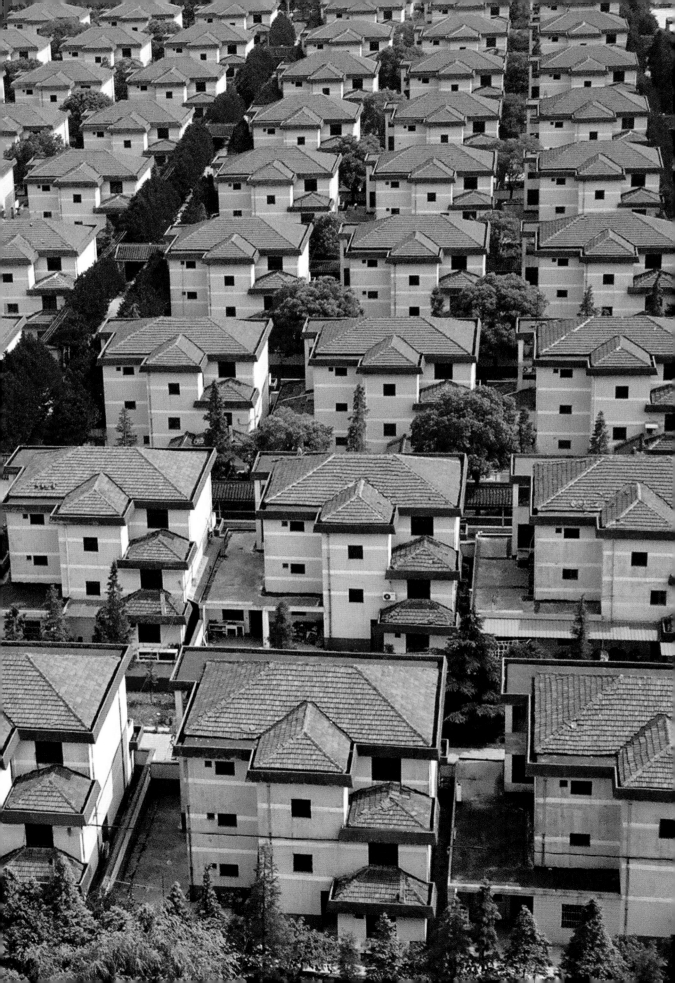

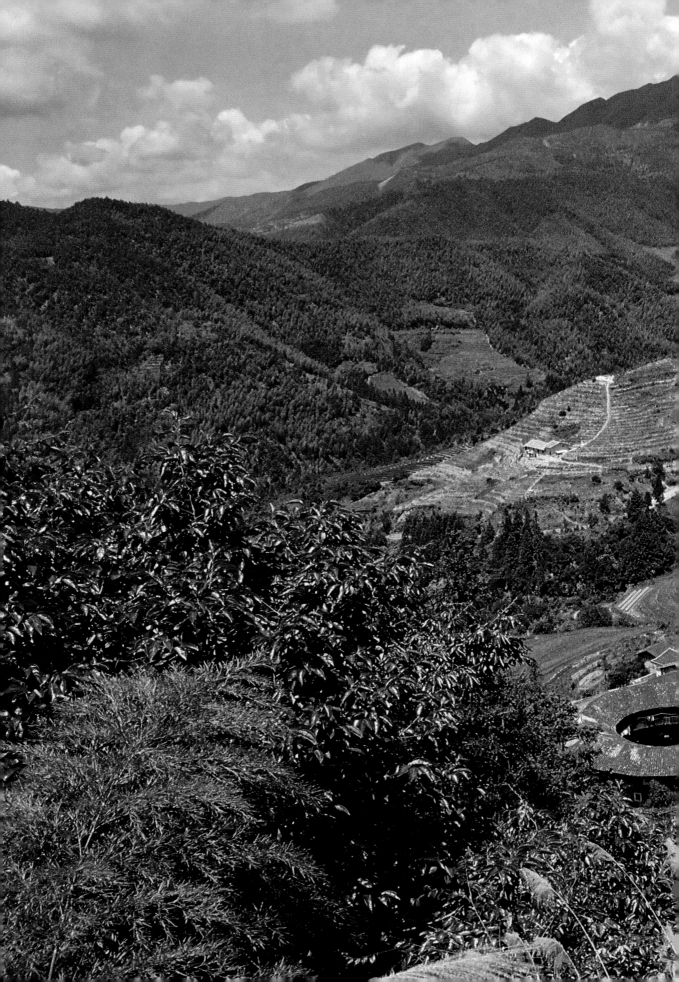

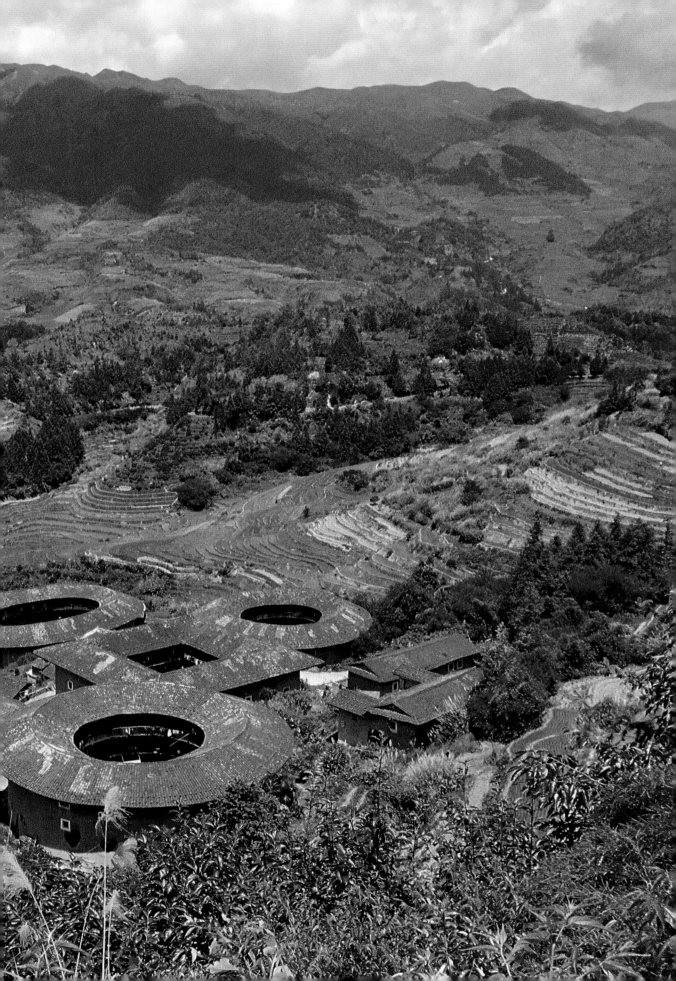

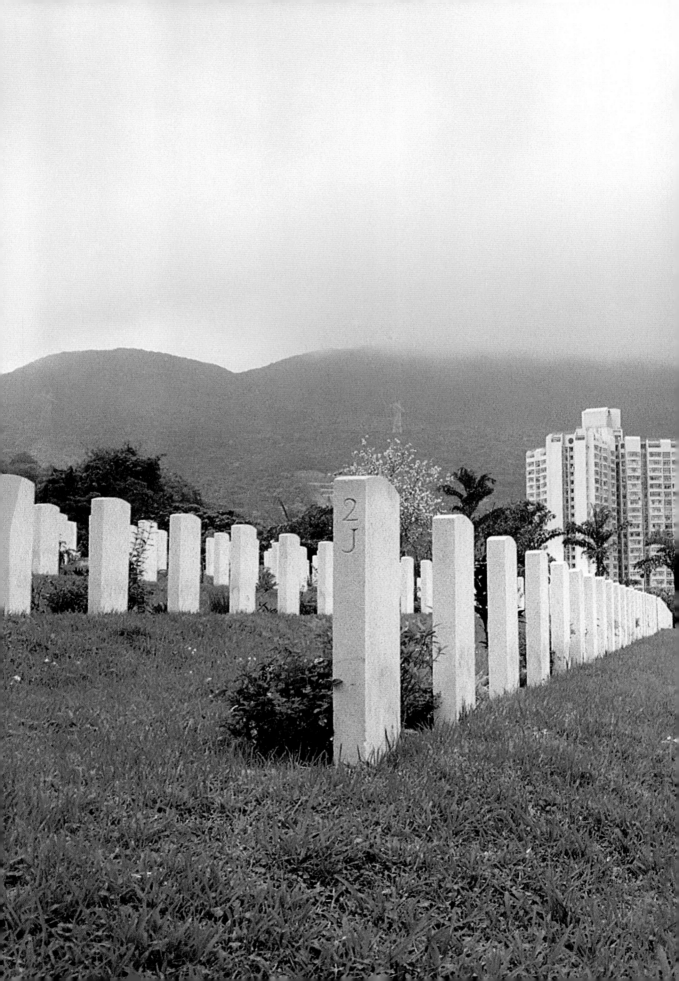

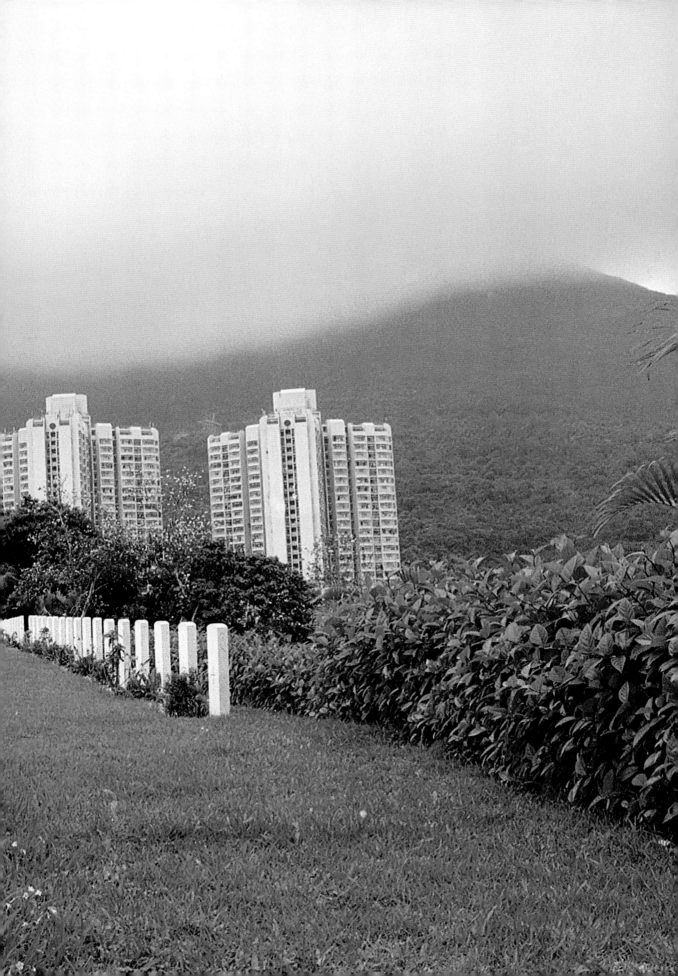

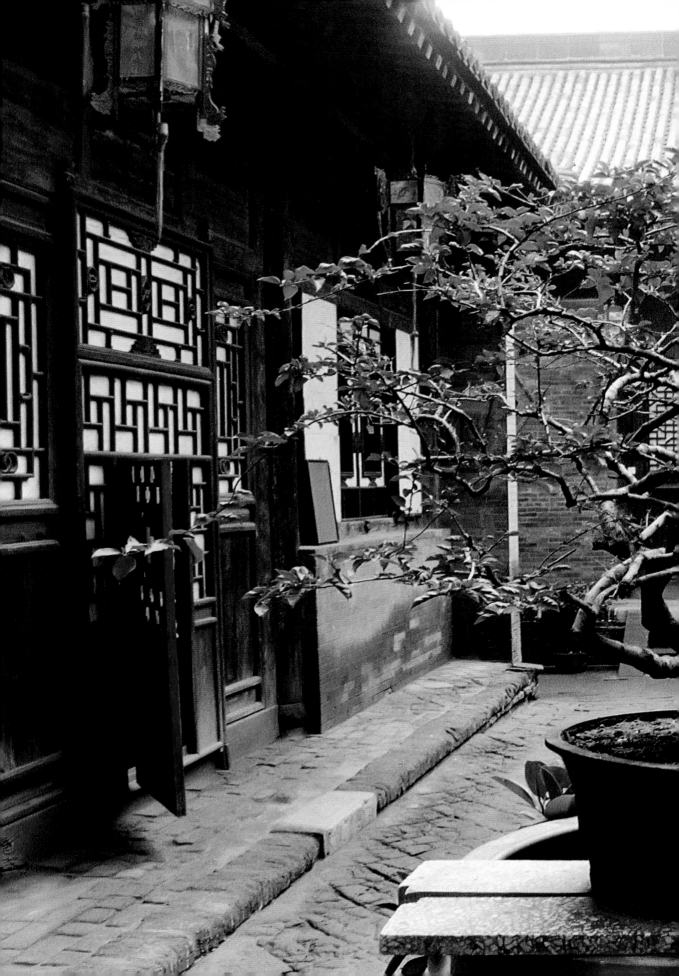

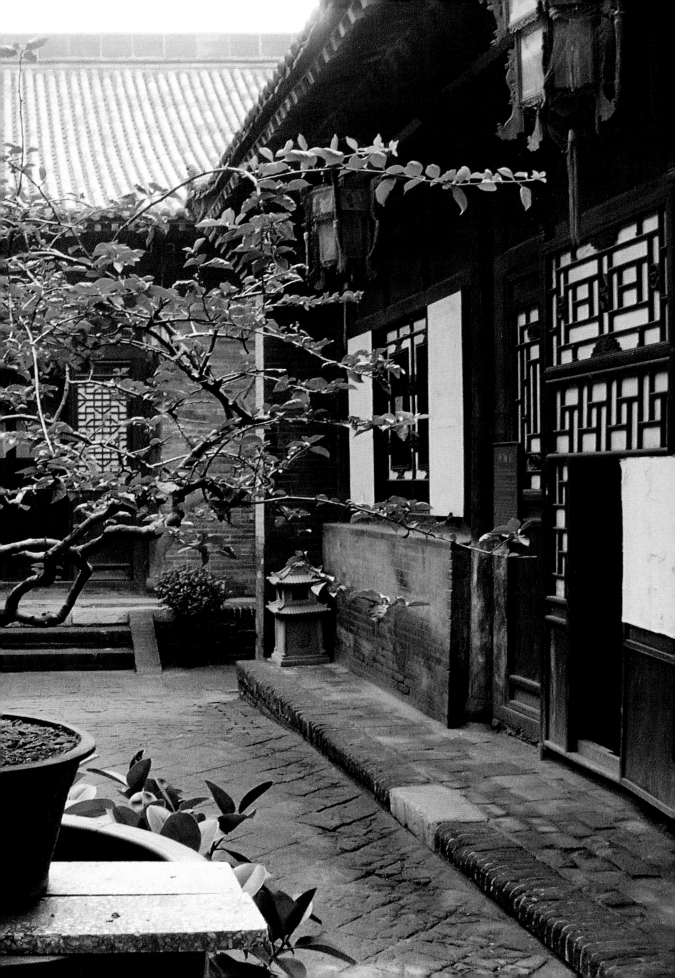

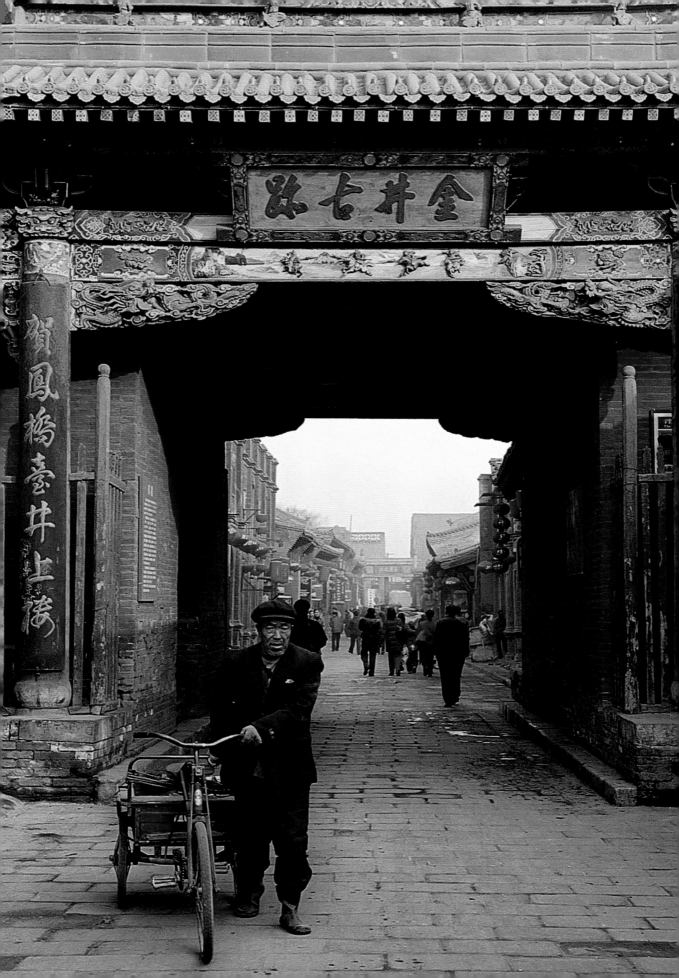

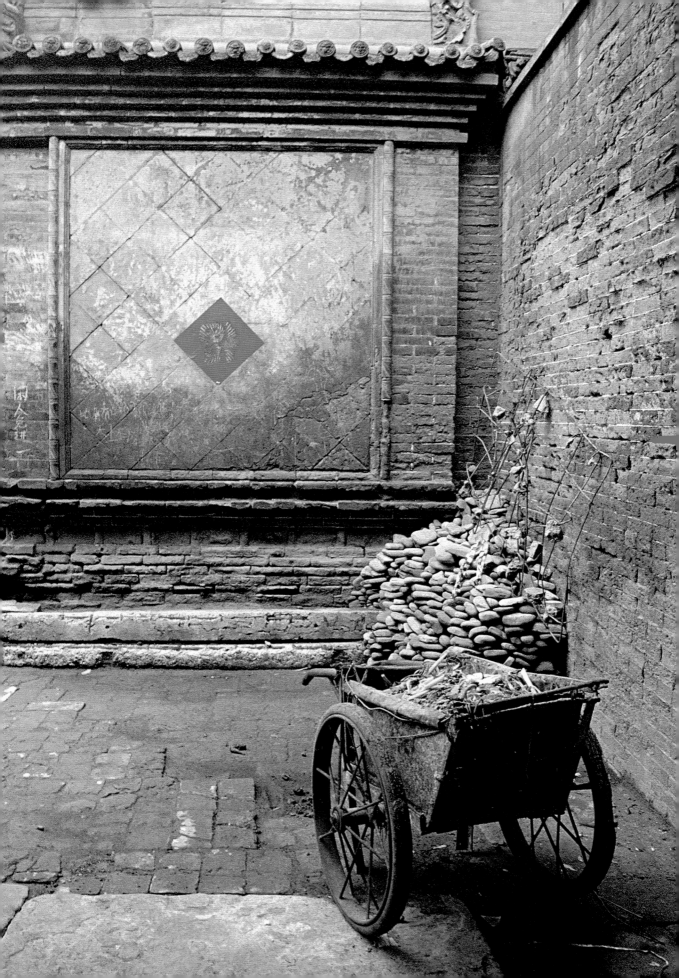

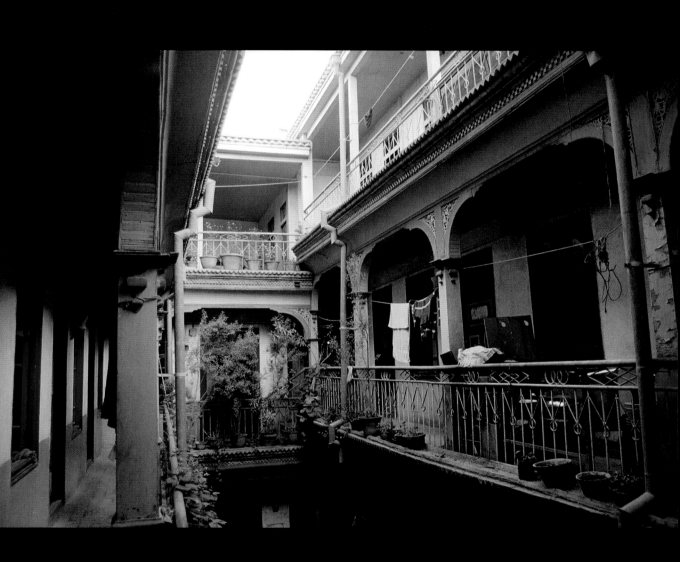

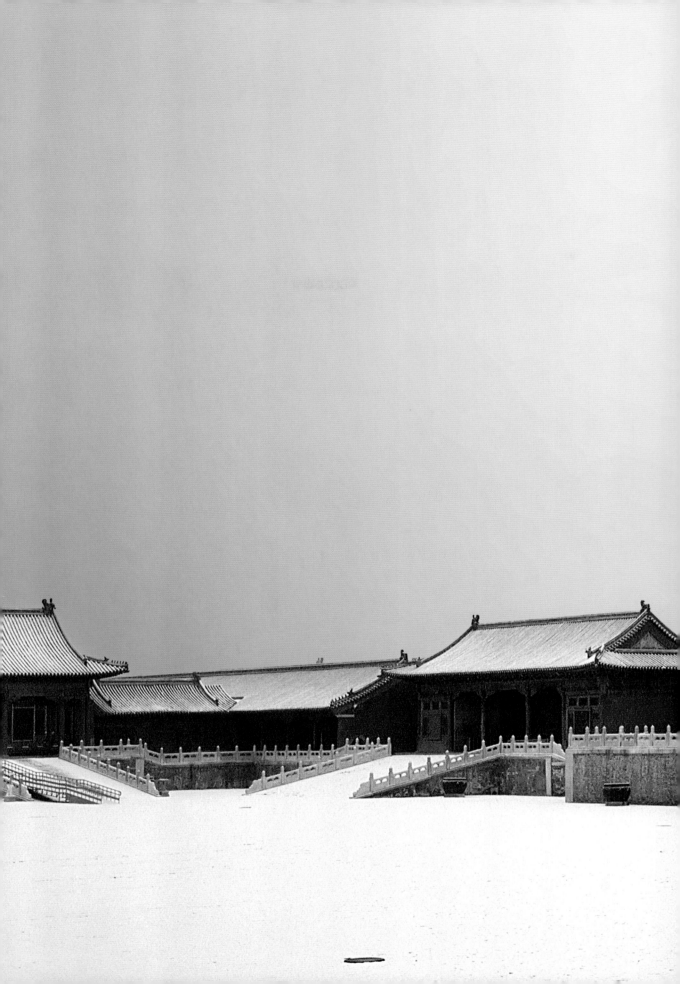

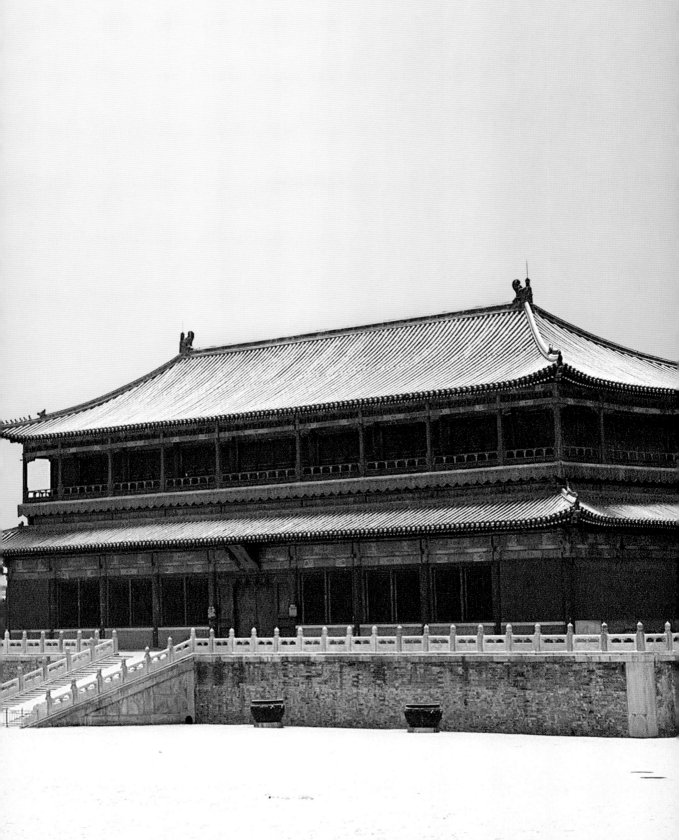

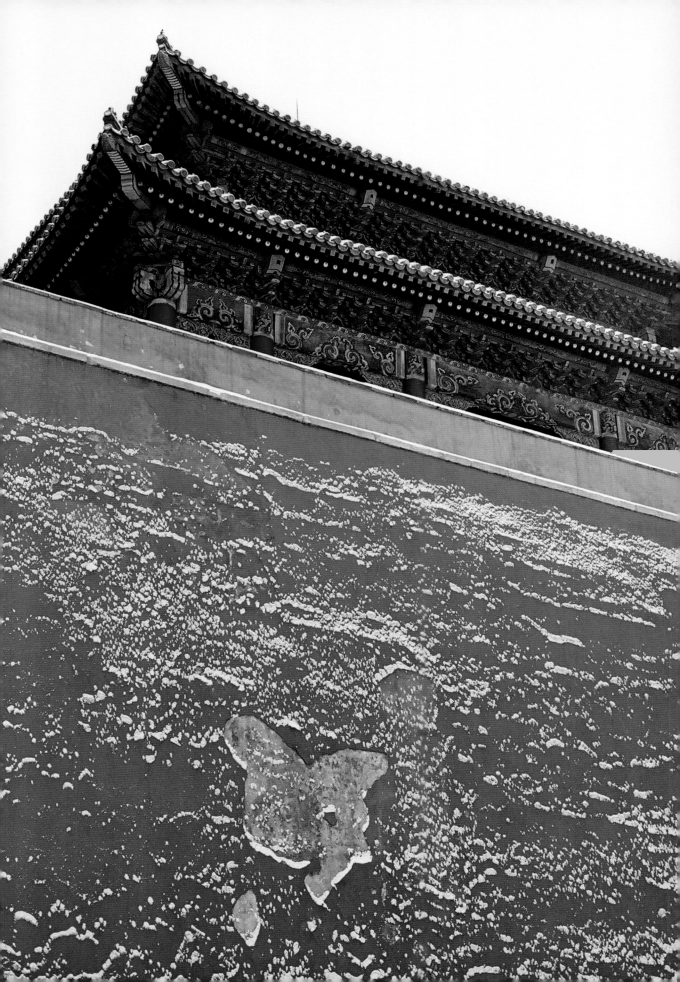

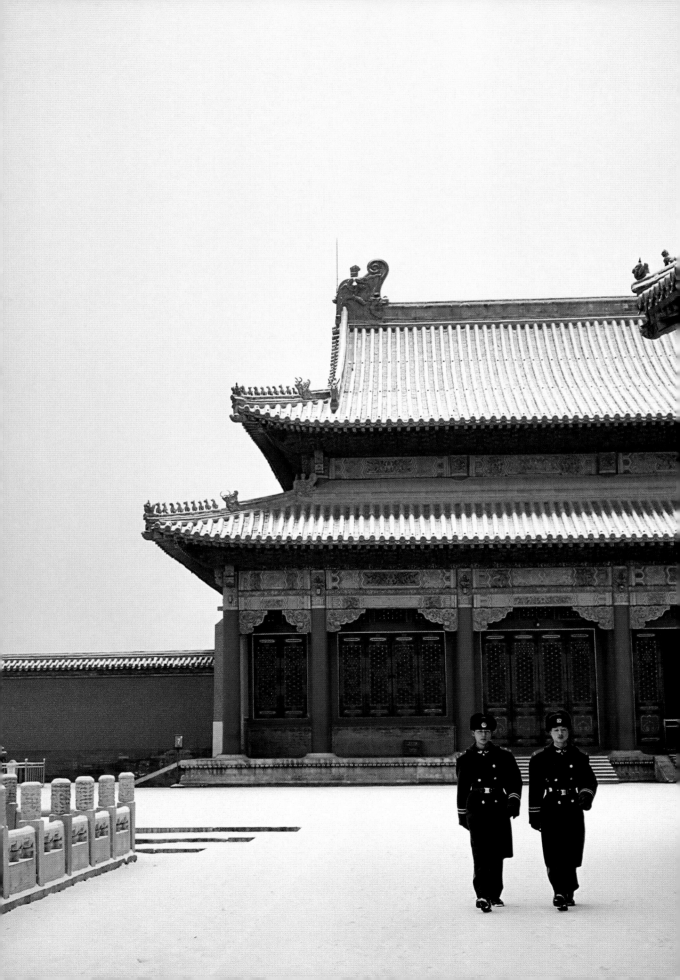

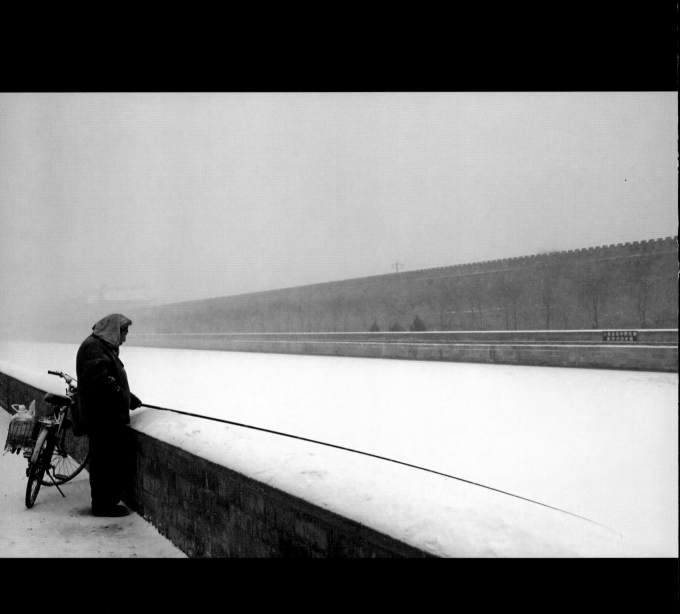

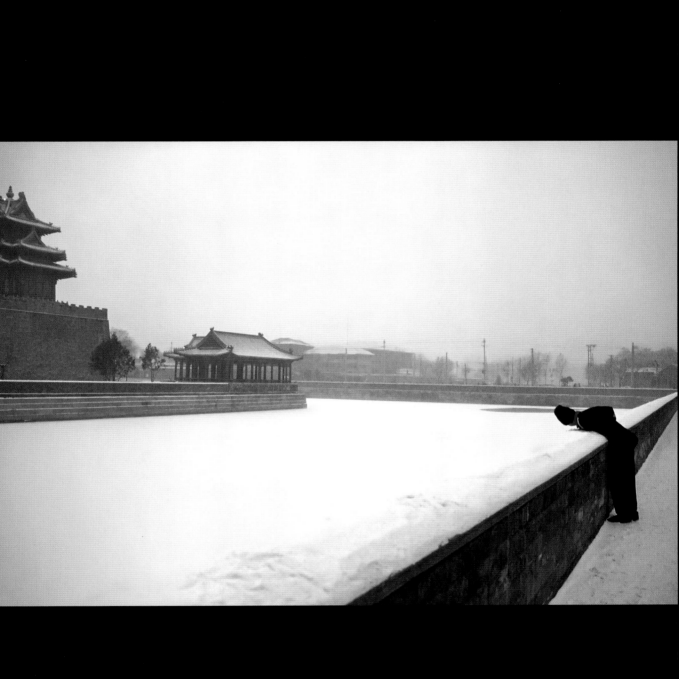

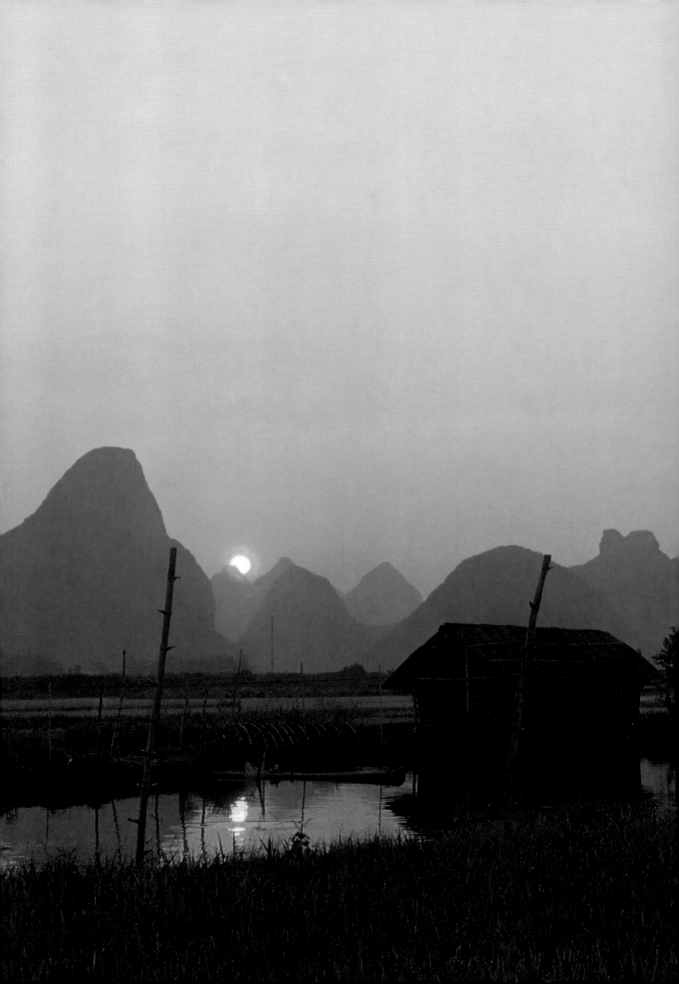

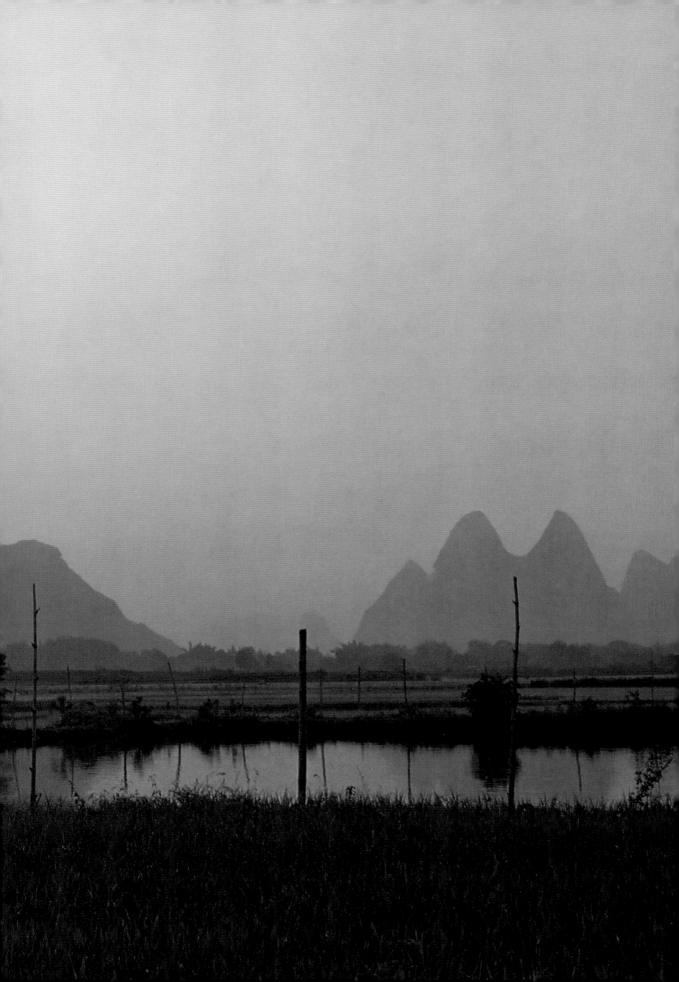

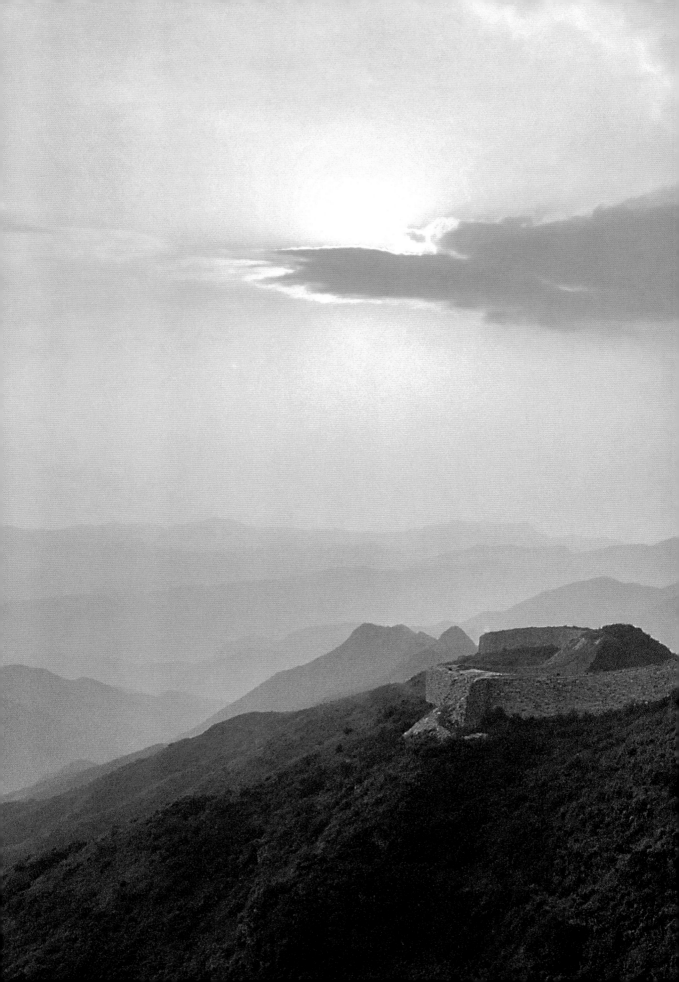

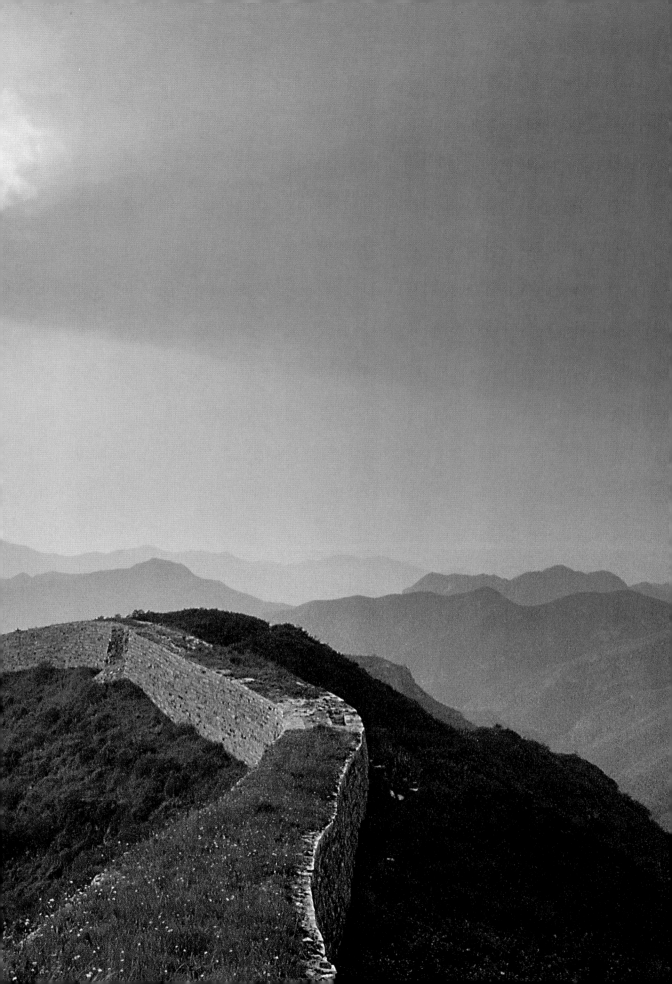

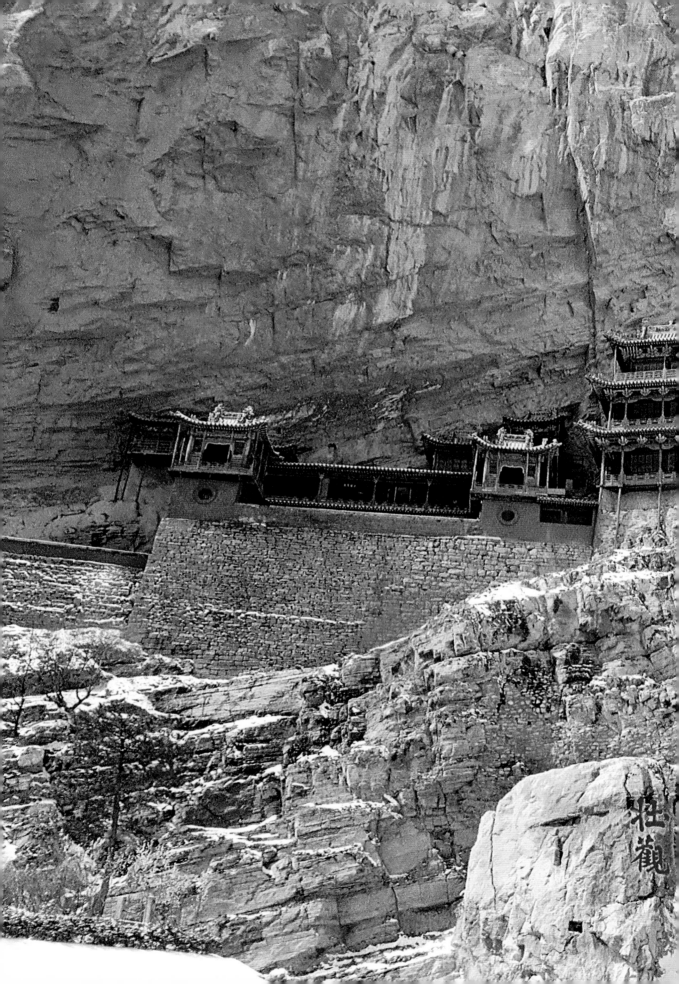

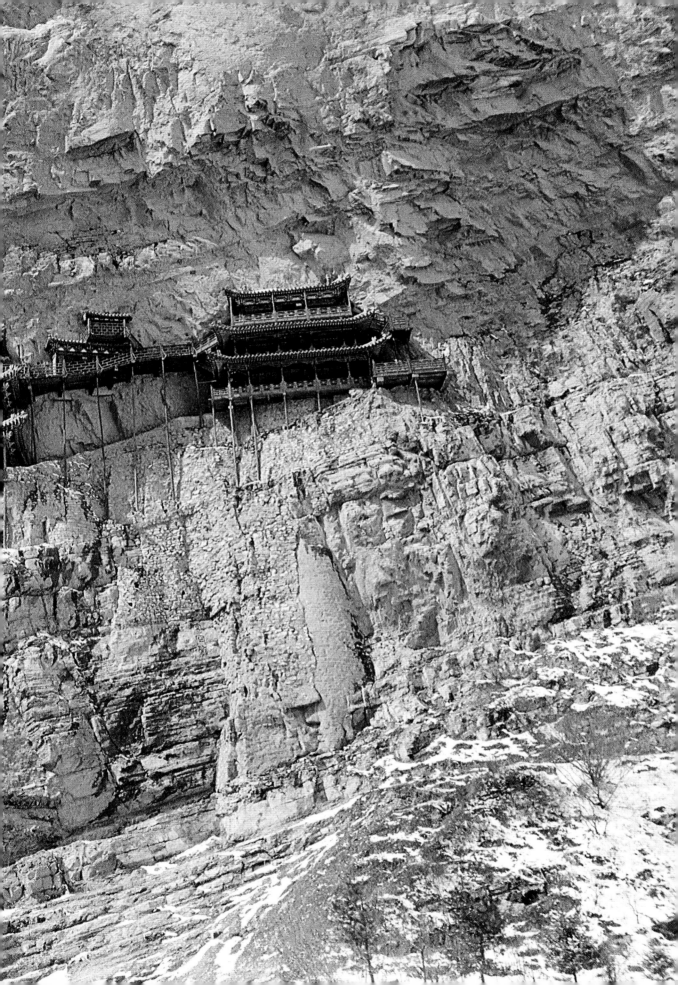

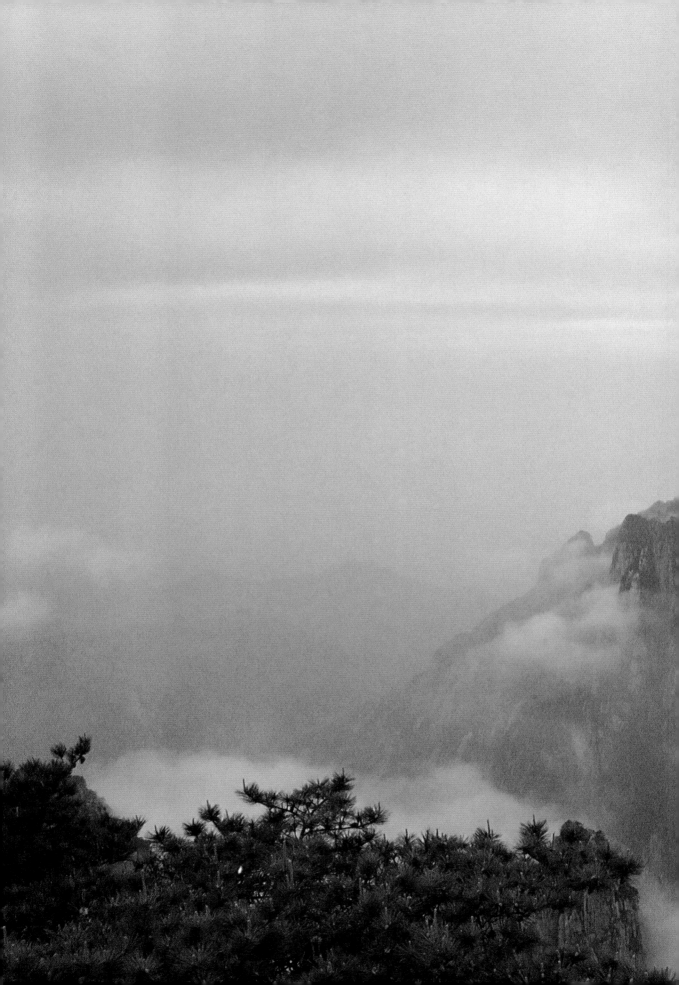

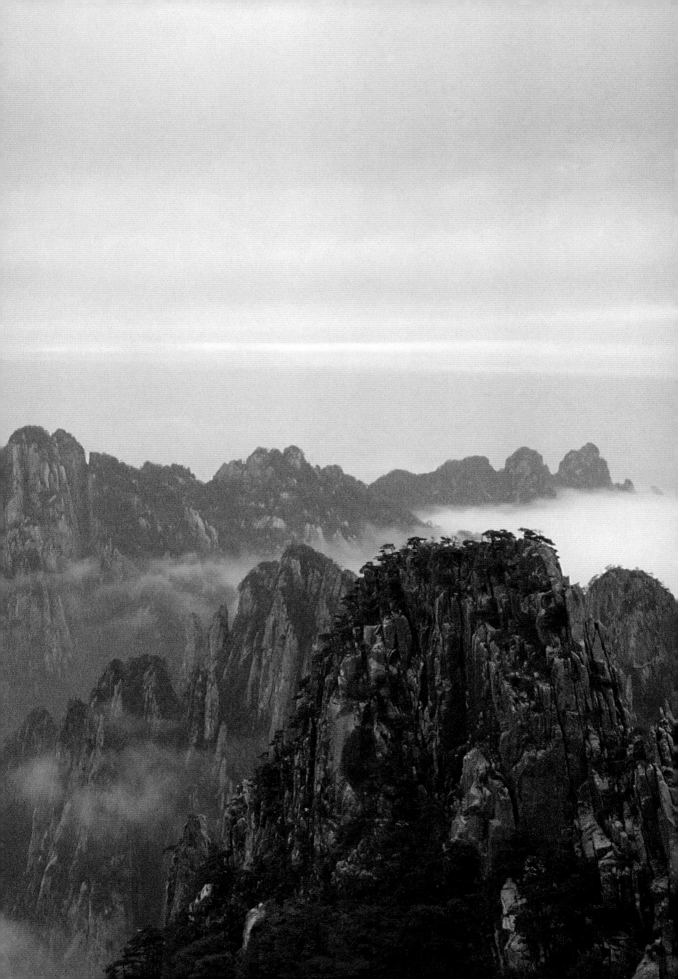

CHRISTINA LIONNET, BIOGRAPHY

Each of us remembers the first time we broke open our piggy bank to buy something important. For Christina Lionnet, it was a camera with a 500mm telephoto lens, almost as big as her head. She lived in Ghana, was thirteen years old, and had one goal in life: to photograph close up the animals of Africa. Over the years, however, Christina began to turn her interest more toward humans than to animals. Sixteen years later, she left the elephants behind to photograph people, and above all, the Chinese people!

Journalist by trade, Christina spent four years in China as a reporter. Convinced that images often speak as well as words, she wandered China with her camera on a strap over her shoulder, ready to capture images of this diverse and ever-changing country.

Jeder erinnert sich an den Moment, wo er zum ersten Mal sein Sparschwein geschlachtet hat, um sich einen wichtigen Wunsch zu erfüllen. Für Christina Lionnet war das ein Fotoapparat mit einem 500mm Teleobjektiv, das fast größer war als ihr Kopf. Sie lebte in Ghana, war dreizehn Jahre alt und hatte eine fixe Idee: die Tiere Afrikas aus der Nähe zu fotografieren. Im Laufe der Zeit verlagerte sich Christinas Interesse mehr und mehr von den Tieren auf die Menschen. Sechzehn Jahre später hat sie sich von den Elefanten abgewendet, um Menschen zu fotografieren, vor allem die Menschen Chinas!

Journalistin von Beruf hat Christina vier Jahre als Reporterin in China zugebracht. Von der Überzeugung durchdrungen, dass Bilder oft genauso viel wie Worte sagen, hat sie mit dem Fotoapparat China durchstreift, um einige Bilder dieses so vielfältigen und in ständigem Wandel begriffenen Landes festzuhalten.

Chacun se souvient de la première fois où il a « cassé sa tirelire » pour s'offrir quelque chose d'important. Pour Christina Lionnet, ce fut un appareil photo, avec un téléobjectif 500mm presque plus gros que sa tête. Elle vivait au Ghana, avait treize ans et une idée fixe : photographier de près les animaux d'Afrique. Au fil des années, cependant, Christina s'est mise à s'intéresser davantage aux humains qu'aux bêtes. Seize ans plus tard, elle a donc délaissé les éléphants…pour photographier les hommes et avant tout les Chinois !

Journaliste de métier, Christina a passé quatre ans en Chine comme reporter. Convaincue que les images parlent souvent aussi bien que les mots, elle a parcouru la Chine l'appareil en bandoulière, afin de capter quelques images de ce pays si divers et si changeant.

Todo el mundo se acuerda de la primera vez que rompió la hucha para regalarse a sí mismo algo importante. Para Christina Lionnet fue una cámara fotográfica con un teleobjetivo de 500mm casi más grande que su cabeza. Vivía en Ghana, tenía trece años y una idea fija: fotografiar de cerca los animales de África. Sin embargo, con el paso de los años, Christina empezó, toma a toma, a interesarse más por los humanos que por las bestias. Así pues, dieciséis años más tarde acabó dejando de lado los elefantes…para fotografiar personas y en especial, a los chinos.

Periodista de profesión, Christina ha pasado cuatro años en China como reportera. Convencida de que las imágenes se expresan a menudo tan bien como las palabras, ha recorrido China con la cámara en bandolera para captar imágenes de este país tan diverso y cambiante.

Ciascuno di noi si ricorda della prima volta che ha "rotto il salvadanaio" per comprarsi qualcosa di importante. Per Christina Lionnet si è trattato di una macchina fotografica, con un teleobiettivo da 500mm quasi più grande della sua testa. All'epoca viveva in Ghana, aveva tredici anni e un'idea fissa: fotografare da vicino gli animali dell'Africa. Nel corso degli anni, Christina si è via via interessata più agli esseri umani che agli animali. Sedici anni dopo, ha abbandonato gli elefanti per mettersi a fotografare gli uomini e soprattutto i cinesi!

Giornalista professionista, Christina ha passato quattro anni in Cina come reporter. Convinta che spesso le immagini comunicano quanto le parole, ha girato la Cina con la macchina fotografica a tracolla per catturare alcune immagini di questo paese così vario e mutevole.

大家还记得为自己购买的第一件非常心仪又十分昂贵的物品吗？对于　　Christina Lionnet（蓝丽妮）而言，是一个照相机，一个有着500毫米远距照相镜头、几乎比她头还大的相机。她曾经在加纳生活过，那时她13岁并且有一个愿望：能够近距离拍摄非洲的动物。一年年过去了，相对于拍摄动物她对拍摄人更感兴趣了。16年后她放弃了非洲那些动物…改为拍摄人，特别是这里的中国人！

　　Christina Lionnet在中国度过了四年的职业记者生涯。她深信图片和语言一样具有说服力，她带着相机走遍了中国，也拍下了日新月异的中国。

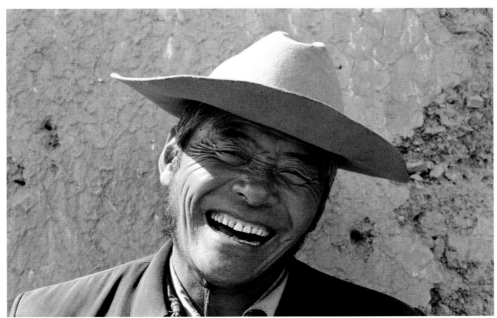

An inhabitant of Sichuan province bursts out laughing.

14/15

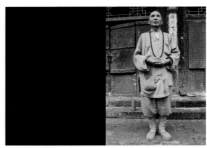

17 Monk at Pingyao, Shanxi province.

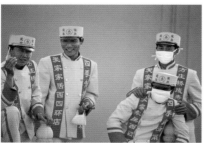

18/19 IKEA's reception staff, masked for protection from the SARS
virus, take a little break in 2003, Beijing.

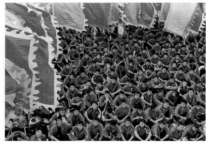

20/21 Students of kung-fu in Shaolin, Henan province.

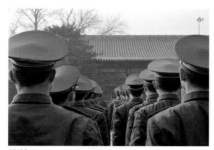

22/23 Guard patrol in the Forbidden City, Beijing.

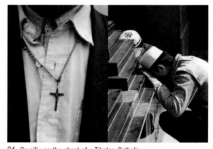

24 Crucifix on the chest of a Tibetan Catholic.
25 Faithful Muslim at prayer in the mosque of Niujie, Beijing.

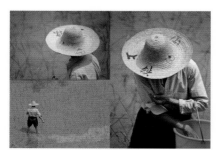

26/27 Peasant in the rice fields, Anhui.

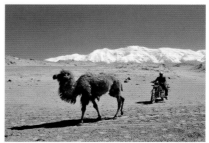

28/29 Inhabitant of the banks of Lake Karakul, with his camel,
Xinjiang province.

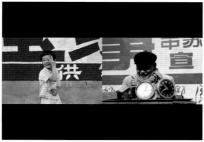

30 Mischievous little boy in Sanpo, Henan province.
31 Repairing alarm clocks in Kaifeng, Henan province.
China is the kingdom of salvaging.

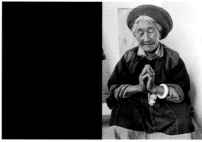

33 Catholic Tibetan woman at prayer, Yunnan province.
Some Tibetan Buddhists were converted by missionaries
in the 19th and 20th centuries.

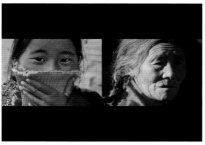

34 Little Tibetan girl of the Sichuan region.
35 Elderly Tibetan woman of the Qinghai region.

36/37 The elegance of "Red Yao" women, Guangxi province.

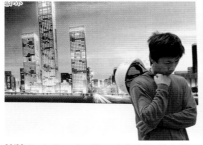

38/39 Construction worker at the work site, Beijing. Most of these
workers are migrants from other provinces who hire
themselves out for a pittance.

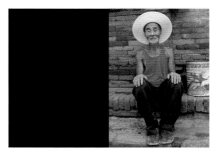

41 Inhabitant of Pingyao, Shanxi province.

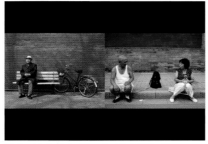

42 At rest in the shade of the walls of the Forbidden City.
43 Encounter between neighbors walking their dogs, Beijing.

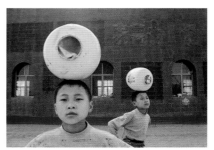

44/45 Child acrobats in the little village of Wuqiao, Hebei province.
The youngest are 2 years old.

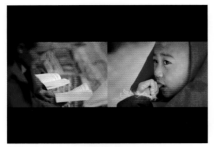

46/47 Monks at prayer near Yushu, Qinghai province.

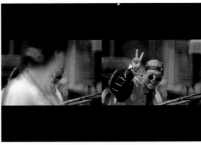

48/49 "Pretty tourist, wouldn't you like to have your picture taken in my rickshaw?" Pingyao, Shanxi province.

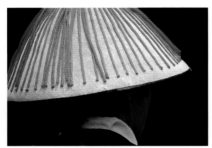

50/51 An "extra" in an historical show in Pingyao, Shanxi province.

CHINESE THINGS
中国物品

52/53

54 The dining table awaits a client in a restaurant in Kaifeng, Henan province.
55 Paint spattered on a wall, Beijing.

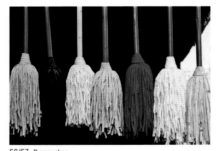

56/57 Broom shop.

58 "Winter".
59 Tea pots.

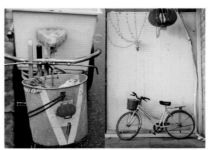

60 In Beijing, tricycles have many uses: trash clean-up or shops on wheels.
61 China: kingdom of the bicycle? Not for very long, perhaps. The private car is dethroning the bike.

62/63 Snare the figurine! At a fair in Hulu Dao, Liaoning province.

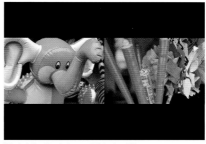

64 An inflatable elephant to delight the children.
65 Paper figures destined for the deceased.

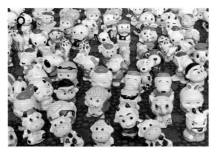

66/67 Amusing toys.

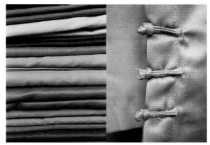

68 "Mao blue" and other shades in a fabric shop.
69 Traditional knotted-button vest: a disappearing style?

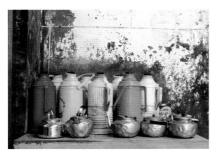

70/71 Hot water bottles, ready for the cup of tea or boiling water served with meals.

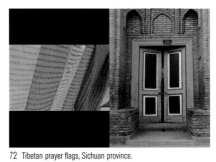

72 Tibetan prayer flags, Sichuan province.
73 Wooden doors in Kashgar, Xinjiang province.

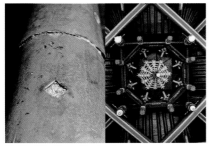

74 Glazed tiles. Pingyao, Shanxi province.
75 Ceiling of the mosque in Xian, Shaanxi province. Detail.

76 Window of a Tibetan house near Shiqu, Sichuan province.
77 Stack of plastic bowls.

78/79 Neon signs in Shanghai.

80 Traditional plastic curtains.
81 Leeks at a market in Beijing.

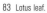

82 Glazed tiles on an old temple in Beijing.
83 Lotus leaf.

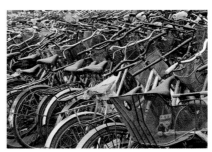

84/85 Can you find yours again? Parking lot for bicycles in Beijing.

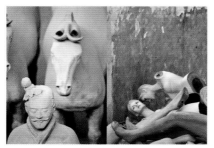

86 Terra cotta soldier of the army buried by the emperor
 Qinshihuang (3rd century BC) in Xian.
87 Mannequins abandoned on a work site, Beijing.

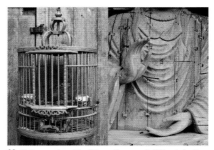

88 Birds, a passion of the Chinese. They were forbidden during the
 Cultural Revolution.
89 Wooden Buddha. Yongtai, Henan province.

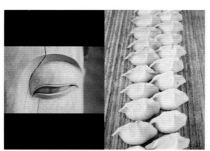

90 Wooden Buddha. Yongtai, Henan province.
91 "Jiaozi", Chinese dumplings. A treat.

92/93
CHINESE PLACES
中国风景

94/95　A lantern on the wall of Pingyao, Shanxi province.

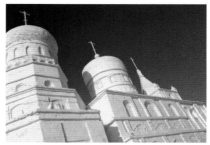

96/97　Life-size snow sculpture at Harbin, Heilongjiang province, bordering Russia.

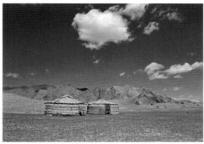

98/99　Kirgiz yurts near Lake Karakul, in Xinjiang province which is bordered by Mongolia, Russia, Kazakhstan, Kyrgyzstan, Tajikistan, Afghanistan, Pakistan, Kashmir, and India.

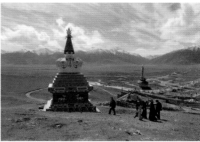

100/101　Buddhist temple and Tibetan pilgrims, Qinghai province.

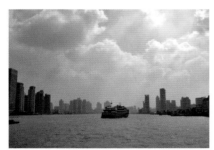

102/103　View of the Huangpu River seen from the Bund, the "fashionable" bank in Shanghai.

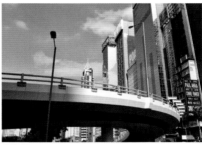

104/105　Highway interchange in Hong Kong.

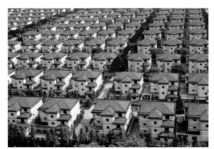

106/107　Villas in Huaxi, known as the "richest village in China", where every resident is said to have his own house and car.

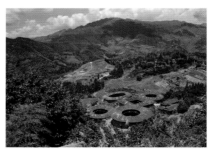

108/109　Roofs of a Hakka fortified house, Fujian province. These round buildings shelter dozens of homes.

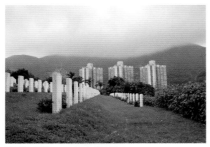

110/111 Military cemetery in Hong Kong.

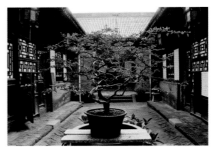

112/113 Courtyard of a house in Pingyao, Shanxi province.

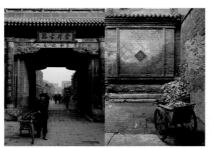

114/115 Alleyways and houses of Pingyao, Shanxi province.

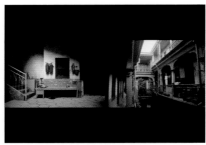

116/117 Ouigur interior, Kashgar, Xinjiang province.

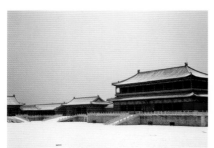

118/119 The Forbidden City (15ᵗʰ century) was the residence of 24 emperors. Beijing.

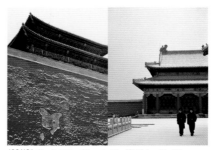

120/121 The Forbidden City, called the "Old Palace," in Chinese, Beijing.

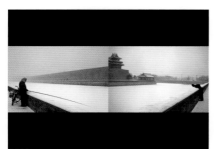

122/123 Fishing in the moats of the Forbidden City, Beijing.

124/125 Terrace of a fortified tower in Kaiping, Guangdong province. These odd fortified houses, in the western style, were built early in the 20ᵗʰ century by Chinese who had made fortunes abroad.

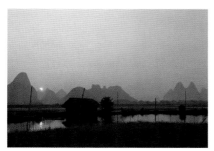

126/127 Karst countryside near Yangshuo, Guangxi province.

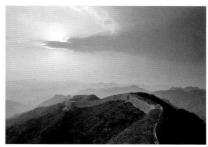

128/129 The wild Great Wall, near Beijing.

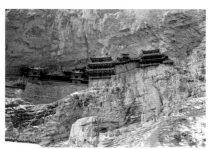

130/131 The Hanging Monastery, Xuankong Si, built 1400 years ago, Shanxi province.

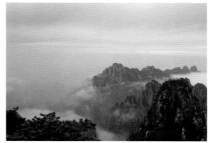

132/133 The Yellow Mountains, for centuries a source of inspiration for painters and poets.

IMPRINT

© 2008 teNeues Verlag GmbH + Co. KG, Kempen

Photographs by Christina Lionnet
© 2008 Christina Lionnet. All rights reserved.

Special thanks

to my parents, sister, brother and friends for their support,
to my grand parents for offering me my first camera,
to Thierry Secretan, who made me discover photography,
to teNeues for trusting this project,
to Kristina Krüger and Alwine Krebber for their
collaboration and understanding,

Texts by Christina Lionnet
Chinese translation by Yang Tingting
Other translations by Zoratti studio editoriale:
Anne Slater (English)
Ursula Varchmin (German)
Concepción Dueso (Spanish)
Simona Mambrini (Italian)

to Yang Tingting, Hui Xiao, Tony Chen, Jean-Luc Oun,
Christiane and Lucile Warter, Gaelle Cauvin, Florence Barreteau,
Lucia Cimadevilla, Chen Feiyun,
to Etienne Dehau, Olivier Föllmi, Marc Dozier, Franck Charton,
Pierre Jaccard, Pierre Bessard, Jean Fontanieu, John Batten,
Gautier Battistella and
to Association Auguste François.

Editorial coordination by Kristina Krüger, teNeues Verlag
Design by Axel Theyhsen, teNeues Verlag
Production by Alwine Krebber, teNeues Verlag
Color separation by Medien Team-Vreden, Germany

Published by teNeues Publishing Group

teNeues Verlag GmbH + Co. KG
Am Selder 37, 47906 Kempen, Germany
Tel.: 0049-(0)2152-916-0, Fax: 0049-(0)2152-916-111
e-mail: books@teneues.de

Press department: Andrea Rehn
Tel.: 0049-(0)2152-916-202
e-mail: arehn@teneues.de

teNeues Publishing Company
16 West 22nd Street, New York, N.Y. 10010, USA
Tel.: 001-212-627-9090, Fax: 001-212-627-9511

teNeues Publishing UK Ltd.
P.O. Box 402, West Byfleet, KT14 7ZF, Great Britain
Tel.: 0044-1932-4035-09, Fax: 0044-1932-4035-14

teNeues France S.A.R.L.
93, rue Bannier, 45000 Orléans, France
Tel.: 0033-2-3854-1071, Fax: 0033-2-3862-5340

www.teneues.com

ISBN: 978-3-8327-9251-0

Printed in China

Bibliographic information published by Die Deutsche Bibliothek.
Die Deutsche Bibliothek lists this publication in
the Deutsche Nationalbibliografie;
detailed bibliographic data is available in the Internet at
http://dnb.ddb.de.